MOAPA VALLEY
Secret Lives
of Common Birds

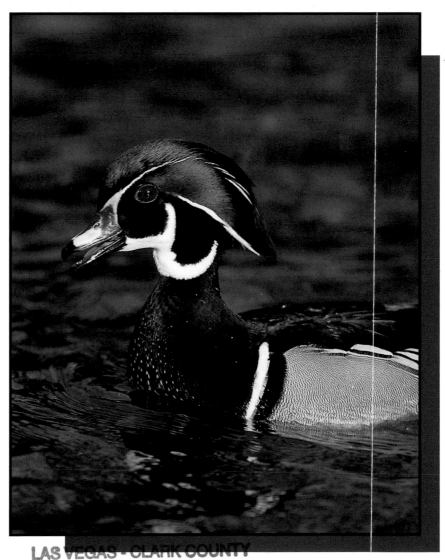

Secret Lives
of Common Birds

*Enjoying Bird Behavior
Through the Seasons*

Photographs and Text by

Marie Read

Houghton Mifflin Company
Boston New York
2005

Visit our Web site: www.houghtonmifflinbooks.com.

Book design by Peter H. Wrege
 Peter Wrege Research, Design & Analysis
 Freeville, New York 13068

Front cover: Black-capped Chickadee on staghorn sumac

Back cover: Killdeer distraction display

Page 1: Wood Duck calling

Pages 2–3: Red-winged Blackbird displaying

Pages 4–5: Snow Geese flying from a misty marsh

Library of Congress Cataloging-in-Publication Data

Read, Marie.
Secret lives of common birds : enjoying bird behavior through
 the seasons / photographs and text by Marie Read.
p. cm.
ISBN 0-618-55871-3
1. Birds—Behavior. I. Title.
QL698.3.R43 2005
598.15—dc22 2005040392

Printed in Singapore

TWP 10 9 8 7 6 5 4 3 2 1

To see more of Marie's photos, visit her Web site at
http://www.agpix.com/mari.

Contents

Introduction

A robin enjoys a bath-time splash at the edge of a pond; a warbler weaves a tiny nest from delicate grasses and plant down; a chickadee hovers for a brief instant to sip from a melting icicle on a winter's day—fleeting glimpses of the secret lives of birds as they strive to survive.

Welcome to the world of bird behavior. It's a world often overlooked by us, with our busy lifestyles. Yet birds are going about their own busy lives all around us; all we have to do is open our eyes and our hearts to them. Spend a little time, and begin a treasure-filled journey that need never end as long as you have birds to watch. You'll notice that birds' lives are strikingly similar to our own as they make a living day by day, driven by the same underlying needs: finding food, water, and shelter, attracting a mate, and raising a family.

Many birders eagerly await every new field guide, hoping for the latest tips for distinguishing subtle field marks and identifying rarities, as they go about adding new species to their lifelists. In this book we suggest a different goal: become truly a bird *watcher*. By concentrating on behavior, you'll find that even the most commonplace birds have interesting, often entertaining, stories to tell. Plus you'll discover the complex ways in which birds' lives are interconnected with each other and with the environment. On this path less traveled you'll never tire of the familiar birds around you. There's always something new to see, something fascinating to discover.

Our exploration of bird behavior takes a seasonal approach, following the changes that take place in birds' lives as the year unfolds. And interspersed throughout are numerous activities that remain important to birds all year round.

So let's set out on our journey to discover the secret lives of our favorite birds!

Above, left to right: Indigo Bunting, American Goldfinch, Blue Jay, and Northern Cardinal.

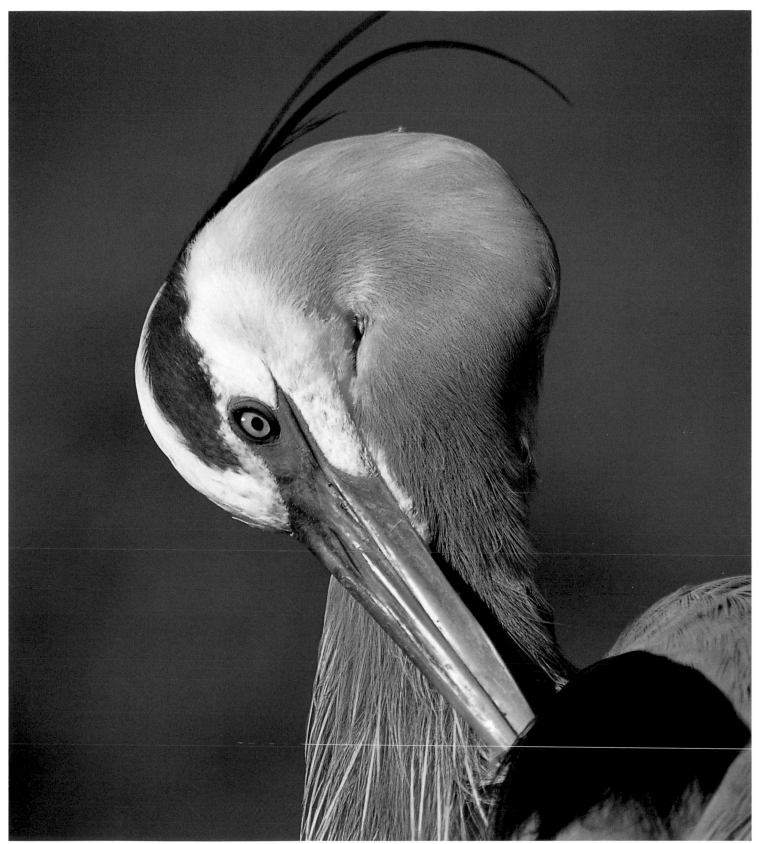

A Great Blue Heron preening.

Spring
Season of Promise

Renewal! Fresh, green-scented breezes stir unfurling leaves as we stretch our legs again in wood and meadow. Life's energy is bursting all around us. Spring flowers bring splashes of color to the quickening woods, and birds return from winter sojourns to fill the air with their delightful songs once more.

Favorite garden birds reoccupy their haunts. Territorial singing and chasing alternate with courtship and nest-building activities. With windows open and more time spent outdoors, we become vitally aware of the small, busy lives unfolding around us.

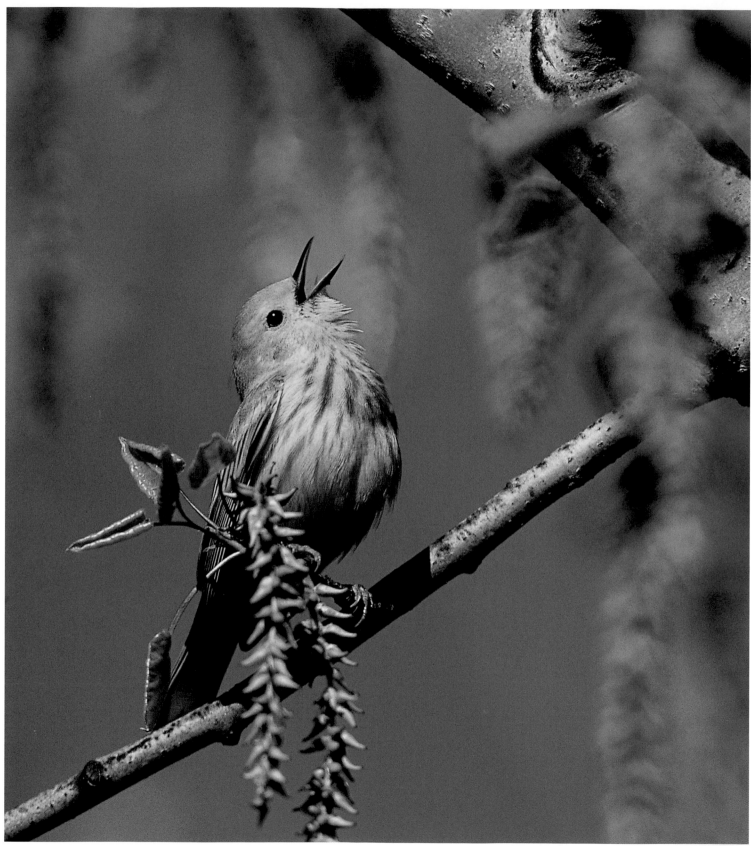

A male Yellow Warbler sings his bright, cheery melody.

Spring Melodies

Spring birdsong! Music to our ears! There's nothing like it to banish the memory of winter's chilly silence and lift our spirits. On a May morning we are treated to a male Yellow Warbler, the color of sunshine, declaring *sweet, sweet, I'm so sweet,* as he pours out his lively song. Farther along on our springtime stroll we find a striking male Rose-breasted Grosbeak putting heart and soul into a richly whistled tune from a blossom-strewn apple tree.

Why do birds sing? We might like to wish it's for our delight or from their own joy of living, but actually those lovely melodies carry a serious message. Birdsong, like most other bird sound, is a vital means of communication from one bird, often the male, to another. Song proclaims territory ownership and tells neighboring birds that the singer is available and is advertising to attract a mate. Even after male and female have set up housekeeping together the male may continue to sing, reinforcing the pair's social bond. Females of certain species sing too: female Northern Cardinals and Baltimore Orioles often exchange songs with their mates, especially early in the nesting season.

The sounds made by somewhat less musically inclined birds, such as owls hooting, doves cooing, and woodpeckers drumming, are also used for territorial defense and mate attraction. Many ornithologists consider these sounds to be functionally equivalent to song.

In a stricter sense, song is the domain of the songbirds, a subgroup of the passerines (perching birds). Composed of especially talented songsters, the songbird club includes many of our familiar backyard types: thrushes, wrens, sparrows, grosbeaks, warblers, and others. What sets a songbird apart from the rest of the world of birds is the elaborate structure of its voicebox, which allows it to produce complex melodious sounds.

Whether a sparrow trilling or a robin whistling, the simple phrases of a warbler or the elaborate flutelike melodies of a forest-dwelling thrush, paying attention to birdsong starts us on the road to behavior watching. Once we've located the singer on its perch, the stage is set for us to notice other activities.

Watch a singing male bird for a while and you'll recognize patterns in his behavior. Which perches does he prefer? How often does he sing at different times of day? What does he do when the female approaches? When another male sings nearby? Take time to look and listen, and enjoy the window birdsong offers us into birds' lives.

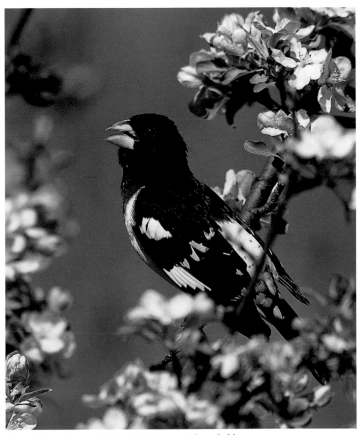

A male Rose-breasted Grosbeak sings amid apple blossoms.

Strutting His Stuff

Ever the handsome ladies' man, a courting Wild Turkey male, or "tom," strikes a regal pose to impress nearby females. With every gleaming feather raised and fleshy neck wattles flushed red, he swishes his drooping wings along the ground, fans out his tail feathers, then slowly struts to and fro.

The Wild Turkey's year is an ebb and flow of sociability. Individuals don't hold breeding territories, and hens nest alone. By summer's end, though, hens and their numerous young start to gather into large flocks that remain together through the winter. Each flock is structured by a dominance hierarchy, or pecking order. Much later in the year, groups of young males often leave the flock, forming male bands that roam widely. They too are ruled by a dominance structure. Older, more aggressive toms may remain loners, keeping apart from the flocks entirely, until hints of spring find them with love on their minds.

As winter fades, roaming toms begin seeking out hen flocks. It's then that the tom lives up to his familiar name of "gobbler," using his far-reaching gobbling calls to attract the females, courting them as they forage. A big dominant tom may monopolize a group of hens as his own harem, enjoying their favors exclusively and aggressively defending them against the advances of lesser suitors.

Yet despite a strong male dominance hierarchy, it's fairly common to see two, sometimes more, toms displaying closely together as a team. They may court the same hen and cooperate to chase off rival bands of males. Surprisingly though, only one male, the dominant one of the team, performs nearly all the matings.

Why should these males tolerate each other's presence when mating and passing on genes are the prize? From the dominant male's point of view, the answer may be that two heads are better than one: a dancing duo is twice as impressive to the ladies as a single performer. But what does the loser get out of this? Why does he stick around playing second fiddle instead of looking for a harem of his own?

One possible explanation is that actually the male teams are siblings. In theory, by helping a brother secure a mating, a subordinate male still contributes genetically to the next generation because, on average, he shares half his genetic makeup with his successful sibling. The unsuccessful male may not have what it takes quite yet, but until he does he can reproduce vicariously through his brother. To solve this puzzle, biologists are currently using DNA analysis techniques to determine whether toms that display together are in fact related.

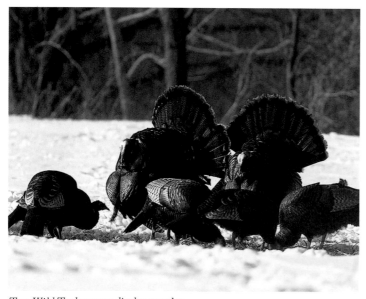

Two Wild Turkey toms display together.

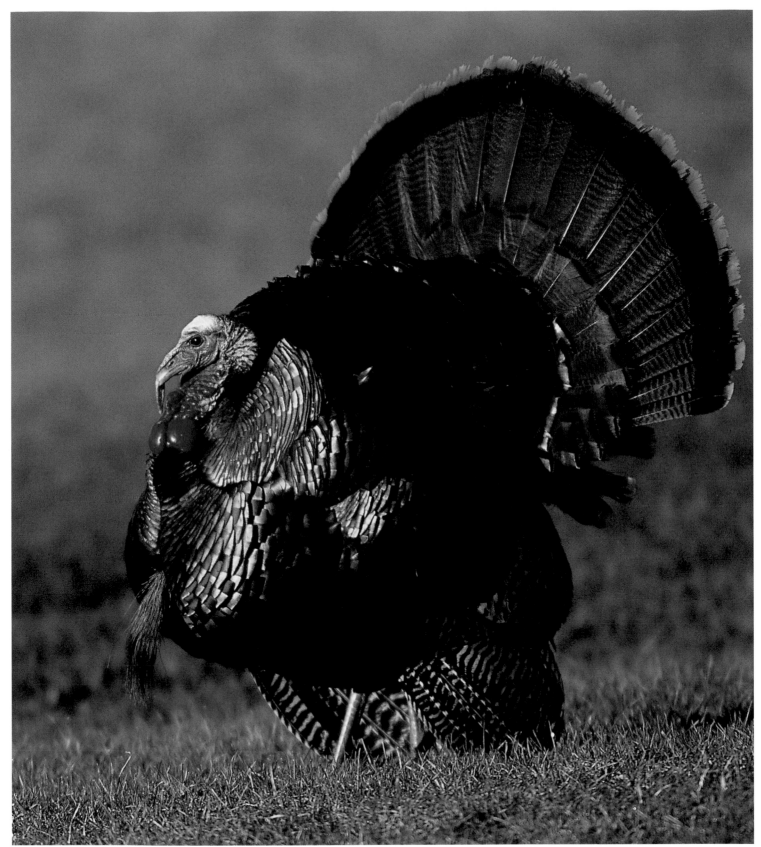

A Wild Turkey tom comes a-courting.

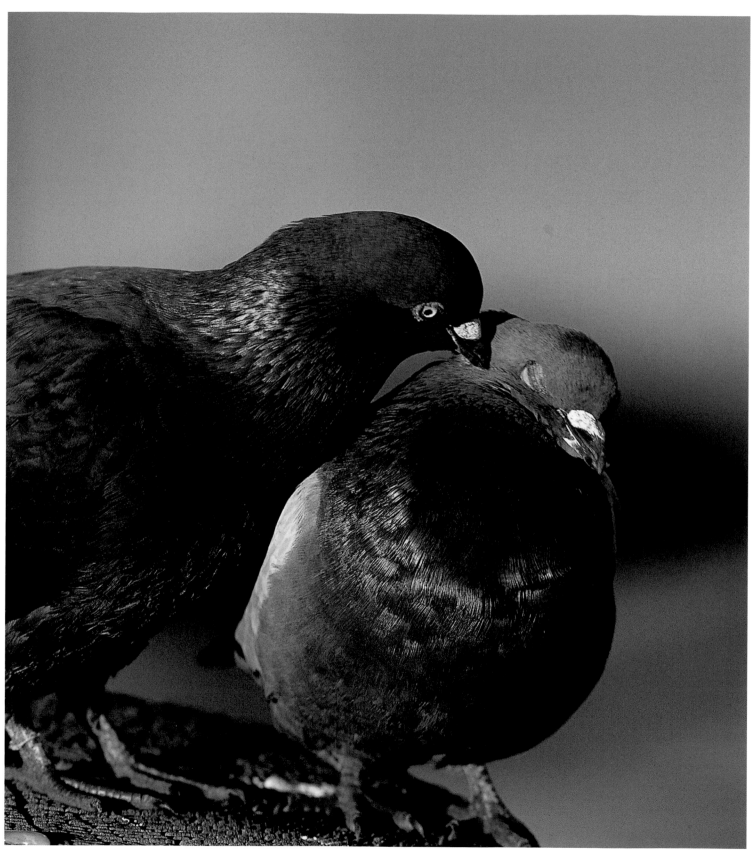

Feels so good! A pigeon preens its mate.

Luvvy-Duvvies

Eyes closed in apparent bliss, a Rock Dove (or pigeon) gets preened by its mate. Birds spend an enormous amount of time preening themselves, but mutual preening (also known as allopreening or social preening) takes place less frequently. It is generally done only by paired birds, particularly when they're near their nest site.

Mutual preening is most often done to the facial area. The bird doing the preening nibbles with its bill at the facial feathers, head, or neck of its partner, which may stretch out its neck or bow down and ruffle its head feathers to facilitate the behavior. Anyone with an itchy back can empathize; it's no wonder that the focus of this activity usually is a part of the body that a bird has the most difficulty reaching for itself.

Very likely, mutual preening acts as much for social bonding as for feather care. Most commonly performed during courtship, it may be seen in doves and pigeons, owls, herons, cormorants, falcons, quail, ducks (such as the courting Wood Duck pair shown below), and various other birds. It's one of several types of courtship behavior that are thought to reduce aggressive impulses and help synchronize breeding readiness between mates.

Among passerine birds, social preening is rather unusual. In North America it's best known in crows, which live in long-term social groups and for which social bonds are particularly important for survival.

Parrots, a group of birds that includes many highly gregarious species, also preen each other regularly. Mutual preening in crows and parrots may take place in social groupings other than between members of a mated pair. Parents may preen their offspring, for instance. So deeply ingrained is the behavior in these birds' social fabric that a pet parrot will often invite head scratching and caressing from its human owner!

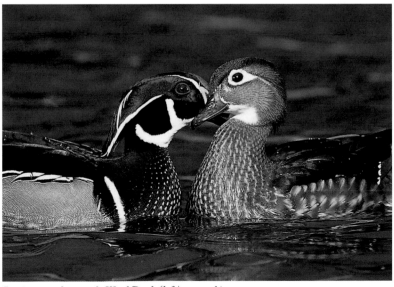

Loving couple: a male Wood Duck (left) preens his mate.

Staking a Claim

The Red-winged Blackbird's display is an audiovisual extravaganza. Flaring out his scarlet shoulder patches and spreading his tail, he calls out a blaring *konk-la-reeee.* Using a distinctive song-flight, with slow wing beats and dramatic red shoulders visible, he flies to and from various prominent perches in the area of cat-tail marsh he has claimed as his own. From each he repeats his display, defining his territorial boundaries.

The courting Wild Turkey tom we met earlier certainly is handsome, but from a hen's viewpoint all he has to offer are genes, impressive though they may be. Male turkeys don't defend territories, so each hen locates a suitable nest site where she will raise her young alone.

On the other hand, the male Red-winged Blackbird backs up his courtship behavior with something tangible: a piece of prime real estate. Most familiar birds around us defend territories during the breeding season. A breeding territory offers the female a safe place to build a nest and often a foraging area too.

The diminutive male Marsh Wren's strategy is real estate development in a big way! First he sings to claim a small patch of marsh. Then the construction boom starts. Bursting with energy, the male begins building nests—lots of nests. He lashes last year's wet cattail leaves around stems, weaving them into softball-size nests. The tiny workaholic makes a dozen or more nests, often working on several at once. Between tasks he hops up onto a cattail to sing his buzzy, rattling song.

When a female arrives, she inspects each of the male's "courting nests" while he displays. Feathers fluffed out and tail cocked over his back, he sways to and fro. If he and his property make a good impression, the female chooses one of the nests and adds a dense, waterproof lining of cattail fluff before laying eggs.

With so many potential homes to choose from, how can a girl resist? Females are picky, though. Some male Marsh Wrens fail to attract a mate at all. Others attract more than one because, like Red-winged Blackbirds, male Marsh Wrens are polygynous and often have more than one female nesting on their territory. It may be better for a female to mate with an already-paired male on a high-quality territory than with a single male on a lesser piece of property.

All those Marsh Wren housing starts don't necessarily go to waste. It's thought they help confuse potential nest predators into missing the active nest. Plus they give the male, and later the fledglings, a roost site.

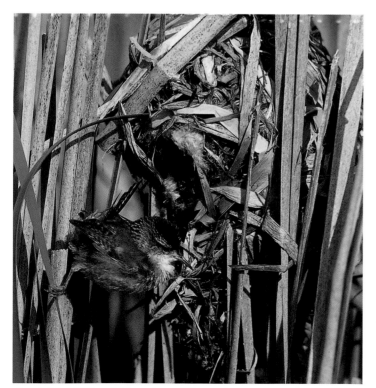

A male Marsh Wren displays at one of his courting nests.

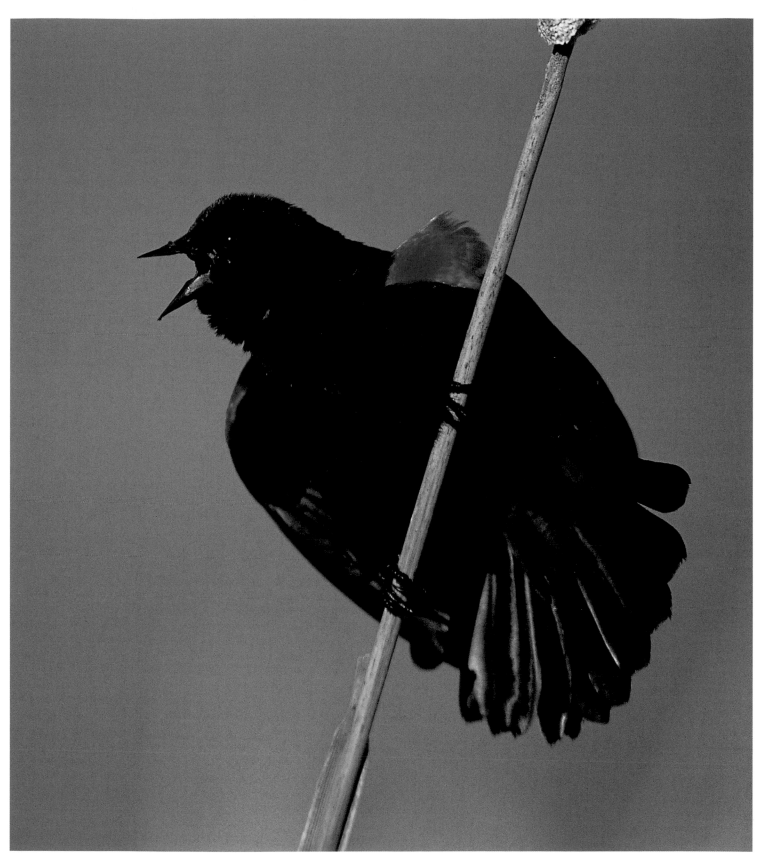

A male Red-winged Blackbird claims his territory.

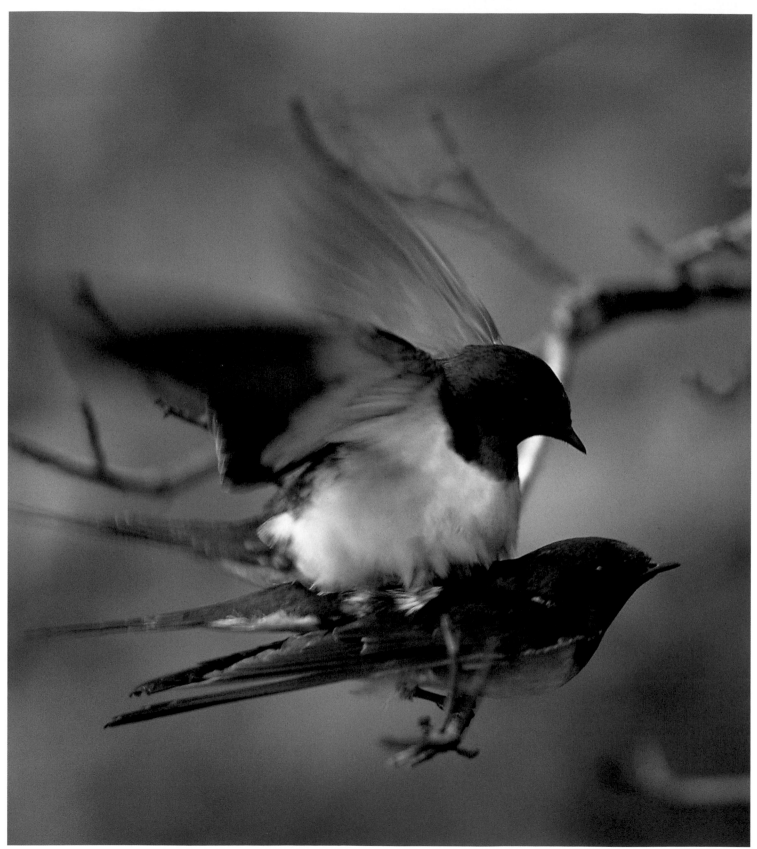

For Barn Swallows, mating is something of a balancing act!

Birds Do It!

With fluttering wings and a subtle maneuvering of tails, Barn Swallows consummate their relationship. For birds, mating (technically termed "copulation") is usually a brief event: in Barn Swallows it takes just a couple of seconds. Not surprisingly, we seldom observe birds performing this intimate act.

The female's behavior may clue us that mating is about to happen. She may lean forward or crouch, raising her tail slightly or holding it to the side. The male climbs on her back, positioning his tail under hers so that their openings (termed "cloaca") meet briefly, an event that ornithologists poetically term the "cloacal kiss!"

In the midst of sexual activity, birds often struggle to keep a balance, looking awkward or even amusing to us. The challenge is mostly the male's. Lacking hands to steady himself, he grasps a tuft of feathers on the female's head or neck with his beak, sometimes spreading his wings for balance. Long-legged birds, such as herons and certain shorebirds, have an even more difficult time. A male Great Blue Heron must manage to squat down to bring his tail into the right position while still standing tenuously on the female's back. Surely lovemaking in birds is fated to remain always for procreation, not recreation!

In fact, for female ducks, mating seems downright dangerous at times. Ducks and geese prefer to mate on water. The amorous male may almost submerge his mate, like the Mallard pair below, making us fear she will drown. She resurfaces safely, though, and the pair excitedly perform their postmating ritual of bathing, preening, and vigorous wing flapping.

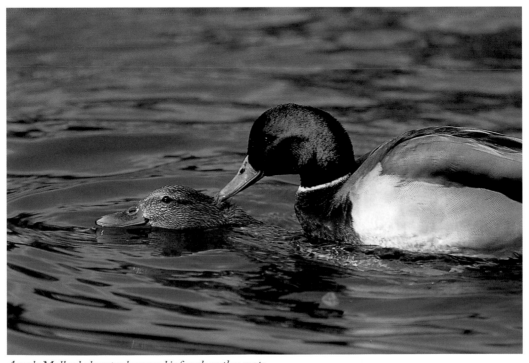

A male Mallard almost submerges his female as they mate.

Reflecting upon Territoriality

In an all-out attack, an American Robin flings itself at the window of a parked sport utility vehicle. Could such rage against the machine be the bird's way of expressing its opinion of gas-guzzling cars? No, it's a more primal response. The car with its shiny window is in the robin's territory, and the bird is attacking its own reflection.

With their hormones flowing in spring, birds are primed to defend their nesting territories from others of their kind. They're simply trying to monopolize the resources they need to raise their young: safe nest sites and adequate food supplies. Females are often just as aggressive as males.

Who is this guy? A male Northern Cardinal flies at his reflection.

Most encounters between competing birds over territorial boundaries end rather quickly. The territory owner may use an aggressive display to let the interloper know it's trespassing on private property. If that fails, it may chase the intruding bird out. Out-and-out fights generally occur only if an opponent stands its ground.

From a bird's viewpoint, that's exactly what happens with man-made reflective surfaces; the reflection seems to be an intruder that simply won't go away. People are often surprised or annoyed at how persistently birds will attack the windows of buildings and vehicles, even car mirrors. Cardinals, sparrows, orioles, catbirds, and mockingbirds, as well as robins, have been observed acting this way, sometimes carrying on day after day to the point of exhausting themselves, as did the male Northern Cardinal on the left.

What can we do to prevent this unnecessary anguish for birds? Try temporarily hiding the reflection on the outside of the window or mirror by covering it with netting or some other fabric. Alternatively, you can disrupt the reflection by drawing streaks across the outer surface of the window with bar soap or attaching patches of plastic food wrap to it. The same methods help prevent a more deadly problem, too: unintended window collisions.

Once the mirror-image intruder disappears from view, the territorial bird will usually resume its normal nesting activities.

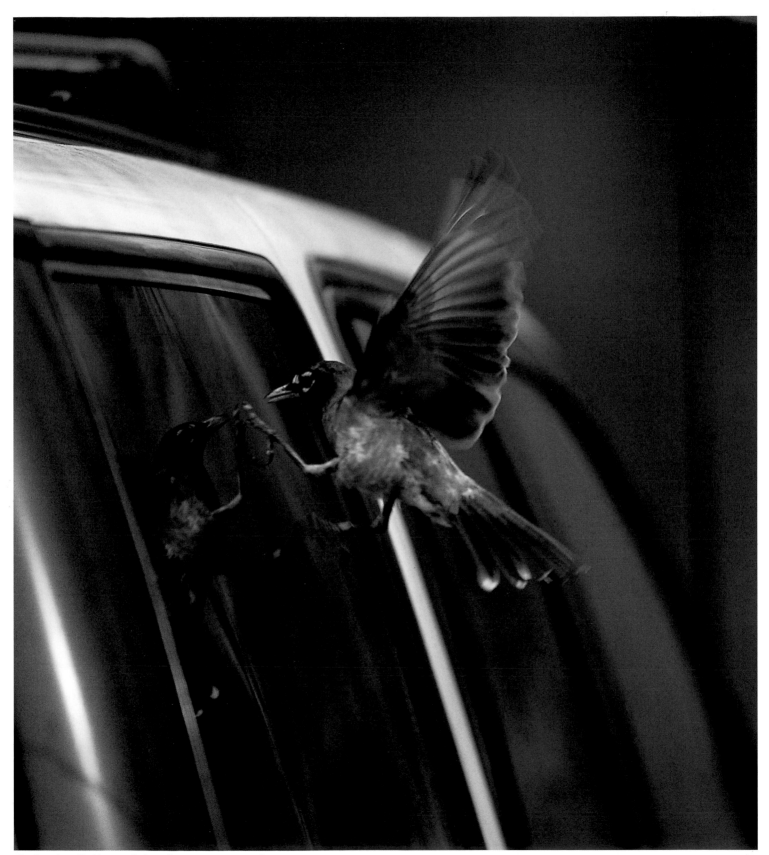

An American Robin attacks its reflection in a car window.

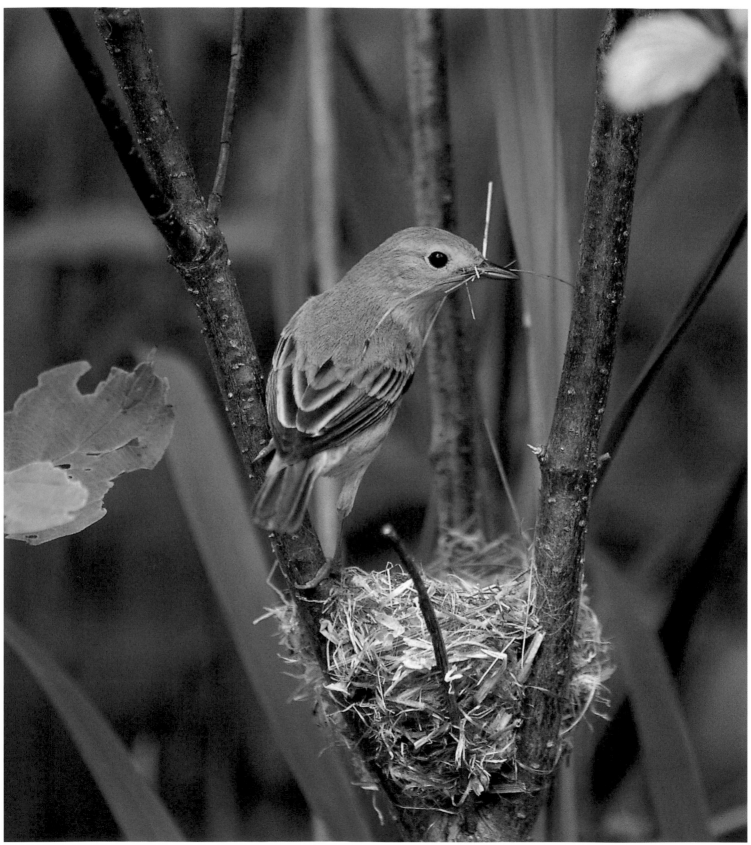

A female Yellow Warbler adds a beakful of fine grasses to her growing nest.

Making a Cradle

She chooses such delicate materials: tiny fragments of plant fiber, fine grasses, and the fluff from willow catkins and cattails. Yet the little cradle this female Yellow Warbler crafts is far from fragile; it's actually an amazingly strong piece of construction work. The secret ingredient? Spider webs!

Over a three-day period, the female adds nest material to the ever-growing pile in the fork of a shrub. After placing each beakful, she crouches down and shuffles around, shaping the material with her body to form a deep cup, tucking and weaving in loose edges with her beak. Sometimes she arrives with an apparently empty beak but still performs the same tucking moves, then sweeps her beak around and over the twigs holding the nest. She is spreading the almost invisible spider webs over the nest rim and onto the supporting stems, using the strong, sticky spider silk as an adhesive to bind the nest material securely in place.

Typical of warblers and many other songbirds, the Yellow Warbler makes her nest alone. She works unobtrusively while her mate sings from a nearby perch. Great Blue Herons could hardly be more different. Nest building for them is a collaborative effort between male and female, accompanied by much elaborate displaying. The couple's teamwork serves not only to construct a place for the eggs but also to strengthen their pair bond.

In spring, Great Blue Herons return to their nesting colonies in secluded wetlands, usually high in the tops of dead trees surrounded by water. Each male lays claim to a nest site, often a nest from a past season. Here he performs his courtship display, stretching up his neck with ruffled feathers and giving deep, moaning calls. Once paired, the male starts bringing sticks to the female at the nest. After more ceremonial neck fluffing and bill clapping, she adds each stick to the saucer-shaped platform. A large stick such as the one below may prove hard to place, so she may reposition it again and again until she's satisfied with its fit.

Unlike the herons, the Yellow Warbler will use her nest just once. If the eggs are taken by a predator early in spring, she will build another nest and try again, but she will produce only one brood per year. Multi-brooded songbirds normally build a new nest for each brood. In Northern Cardinal families, for instance, dad takes care of the first set of fledglings while mom is off building a home for her second clutch. Eastern Phoebes are among the few songbirds that reuse their first nest for later broods, but not without a little renovation.

Birds that reuse the same nest from year to year are even more unusual. Large birds of prey, such as Bald Eagles and Ospreys, may reuse nests for many years, adding new material year after year. Such nests can become enormous.

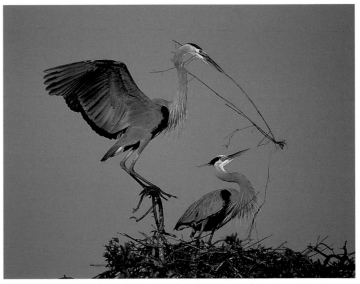

A male Great Blue Heron brings a stick to his mate at the nest.

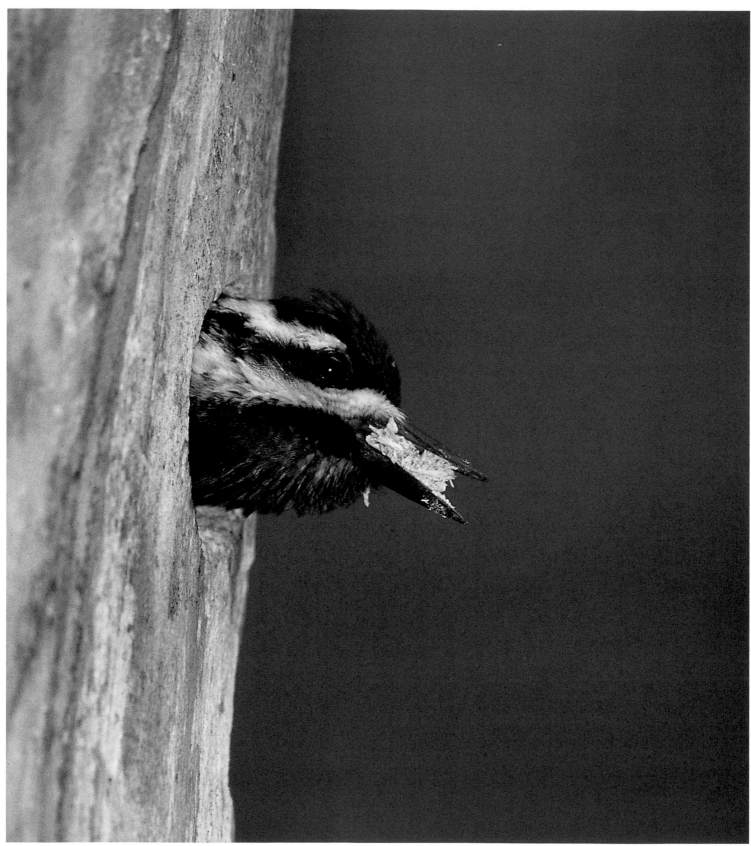

Digging in: a male Yellow-bellied Sapsucker removes wood chips from his nest hole.

Carpenter Birds

Emerging with his beak full of wood chips, a male Yellow-bellied Sapsucker has almost completed his nest hole. Taking turns to chisel with their strong bills, male and female work a week or more to excavate a gourd-shaped cavity inside the tree where they will soon raise their family.

When the pair first begin their project, the discarded wood chips fall directly to the ground. As the digging progresses deeper into the tree trunk, though, they laboriously carry the fallen wood chips one beakful at a time to the entrance hole and toss them out. Males do most of the digging, even sleeping in the nest hole each night during construction.

Sapsuckers, like most woodpeckers, dig a new nest hole each season. Usually they choose a dead tree or stump, often one where they've nested before, but sometimes they prefer a living tree. A live aspen infected with heartwood fungus is especially desirable real estate. Its soft, decaying interior is easy for the sapsuckers to excavate, yet its intact outer surface forms a tough living shell to deter predators. Eggs are laid on the unlined floor of the hole.

And in future years, other birds benefit from the sapsuckers' hard work. Abandoned sapsucker nest holes make ready-made homes for certain birds termed secondary hole nesters, such as titmice, nuthatches, bluebirds, and certain wrens, swallows, and flycatchers. These small songbirds still build cup nests of vegetation, which have the additional security of being hidden inside a tree trunk.

Somewhat surprisingly, given their small beaks, Black-capped Chickadees prefer to dig their own nest holes, using old woodpecker holes only if they can't find a suitable place to excavate. Why go to such trouble?

Chickadees must weigh the costs of using a second-hand nest against the benefits. By making a new hole, the chickadees get an entrance that fits them exactly, making it safer from larger intruders, plus they can avoid skin parasites that may still lurk in old nest holes.

The chickadees choose a rotten snag or knothole, whose decayed wood is soft enough for them to excavate. Both members of the pair take turns digging, painstakingly carrying off wood chips by the beakful and dropping them at a distance so they leave no visual cues to predators that a nest is present. Finally the female builds a nest of grasses, moss, and fur inside the completed cavity to hold the eggs.

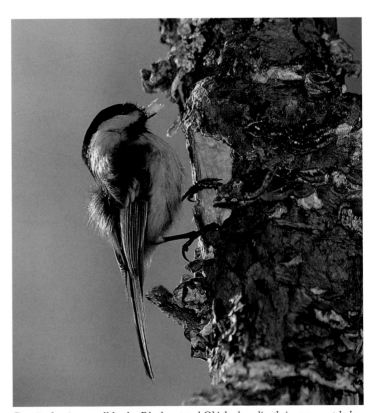

Despite having small beaks, Black-capped Chickadees dig their own nest holes.

Home Style

For most of us, the term "bird's nest" conjures up an image of a cozy bowl made of twigs that safely cradles a bird's delicate eggs and often the developing young. Yet beyond that basic design, the diversity of nest shapes, styles, and building materials is surpassed only by the variety of birds themselves.

Nests vary from simple to elaborate, and from small and compact to bulky and untidy. Some consist of layers of different types of material; others, like the ground scrapes of plovers, are made of nothing at all. A nest may be located high in a tree, on the ground, in an earthen burrow or tree hole, or almost anywhere in between.

The skilled builders themselves range from master weaver to expert potter. And they achieve their amazing goals not using tools in practiced hands as we do, but merely with their beaks and occasionally their feet!

Consider the Baltimore Oriole's beautiful hanging nest. Woven of plant fibers, hair, and sometimes twine

or other man-made materials, it's lashed to the tips of the outer branches of a tall tree. It's built by the female oriole alone. She starts by winding long fibers around a chosen twig, adding more and more until she forms a hanging snarl of material, randomly woven together. Bringing more material, the female pokes and tucks the fibers into place with her beak, weaving in more supporting twigs. Finally she begins to work from what will eventually be the inside of the nest, neatly filling in the sides to make a dense fabric, and lining it with cottonwood fluff and other soft plant materials. The completed nest may sway dizzyingly in the wind, but it's very strong and attached firmly enough to withstand all but the worst weather.

The Barn Swallow, master of the air, must come down to the ground to gather its chosen nest material: mud. Male and female share the building process, making numerous trips to and from their nest site, in a barn or other building, or under a bridge, carrying pellets of mud, mixed with vegetation, in their beaks. First they make a mud ledge on which they can stand as they build up the sides of the nest. If the nest is built on top of a supporting structure, it ends up being a cup shape. Built against a vertical wall, though, like the one on the left, it becomes a semicircular half-cup.

Before the swallows lay their clutch, they line the mud cup, which by now has dried rock hard, with fine grass and feathers. Because they are usually protected from rain, the mud nests sometimes stay intact for many years. Barn Swallows often reuse them in subsequent years, adding more and more mud to the rim so that old nests may become quite deep. A typical Barn Swallow nest may contain 750 mud pellets; a large old one may be made of twice as many!

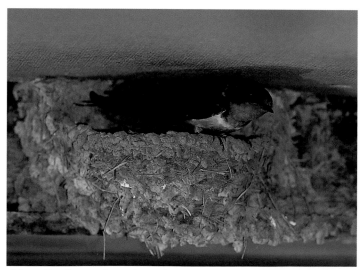

A Barn Swallow perches on its mud nest.

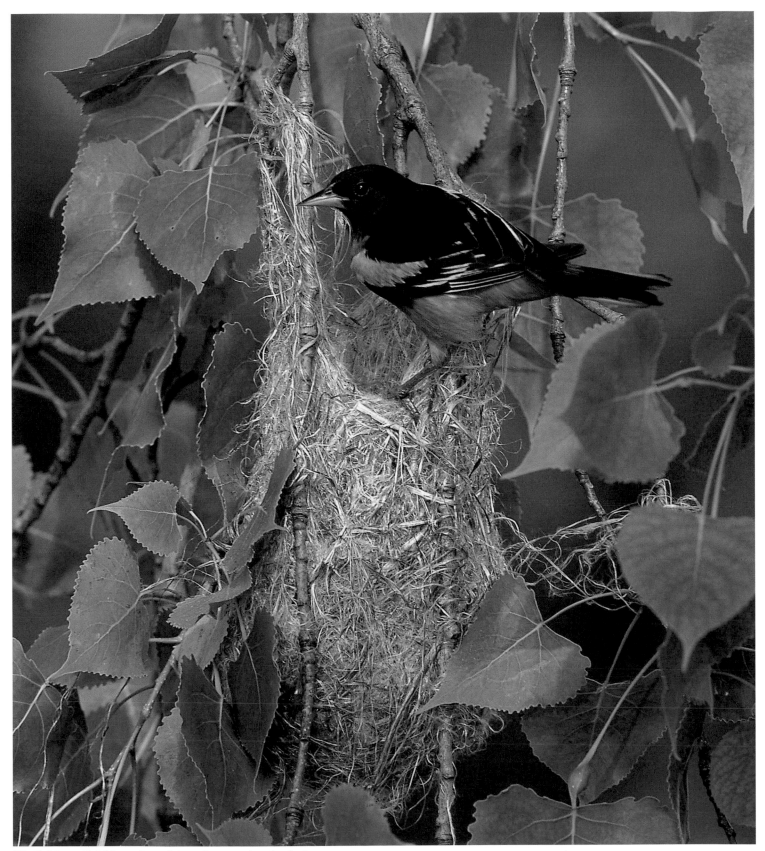

The Baltimore Oriole's nest is an elaborately woven hanging basket.

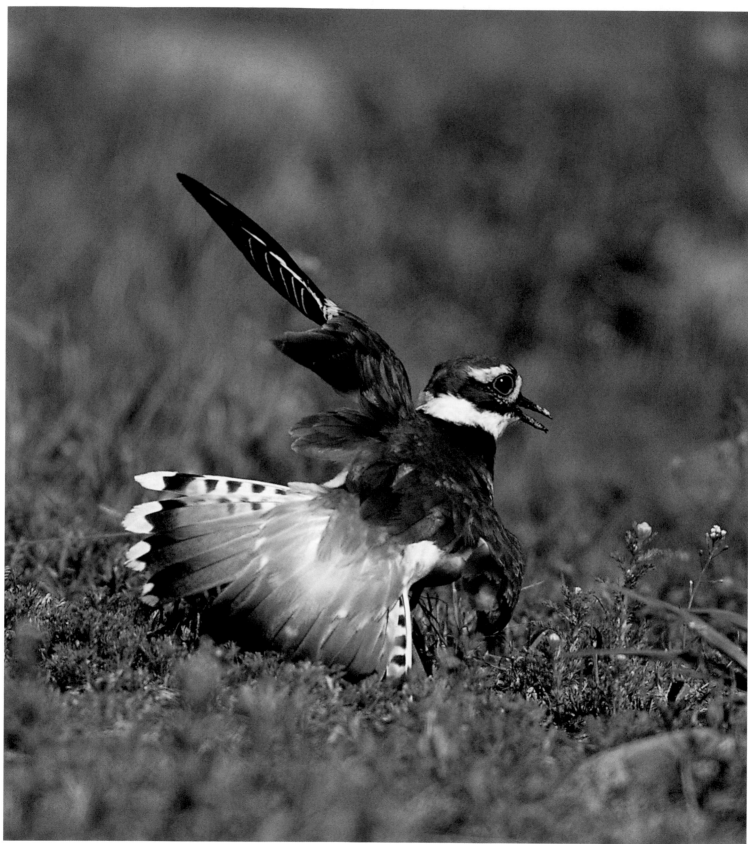

A Killdeer feigns injury to distract an intruder.

Dance of Distraction

A Killdeer flaps awkwardly along the ground, wings dragging and tail fanned to reveal a chestnut rump. Surely the poor bird is wounded and unable to fly, an easy catch for a predator. Try following it, though, to remove it from harm's way and it scurries off, keeping just ahead of you, crouching and fluttering, crying piteously as it watches your approach over its shoulder.

It's all a fake! Suddenly the bird recovers and takes flight, circling back in a wide arc to where it started this bizarre behavior. You've been fooled, like many before you, by the Killdeer's injury-feigning display. Also called the broken-wing display, this convincing deception is performed to distract predators away from the bird's nest nearby on the ground.

Woodland birds can hide their nests high in trees or deep in dense shrubbery to keep their eggs and young safe, acting secretively to avoid giving away the nest's location. Birds of open country, particularly sandpipers and plovers, such as the Killdeer, have nowhere to nest but on the ground and often in exposed locations. Their antipredator strategy is to deliberately draw attention to themselves.

Broken-wing displays occur in most shorebirds, as well as other types of birds, ground-dwelling and otherwise, from doves to quail to ducks. Sandpipers, ground-nesting sparrows, and other birds perform a display known as the "rodent run." The bird crouches low to the ground as it flees the nest, with trailing wings and squeaking calls, looking like a small scurrying mammal. What hungry predator could resist such a prize?

The clever Killdeer can even tell whether or not an approaching animal is truly predatory. It generally restricts its broken-wing display to intruders likely to eat its eggs or chicks, such as foxes, raccoons, and opossums. The deception works, too: biologists watched more than a thousand situations in which predators approached Killdeer nests. The animals were successfully lured away in all but a handful of cases.

Faced with a nonpredatory intruder, such as a grazing farm animal that threatens to crush its nest, the Killdeer uses a different ploy. Trying to tempt a cow away with the promise of a meaty meal would be a waste of time, so instead the bird aggressively flies toward it, screaming loudly.

If this fails, the bold Killdeer raises its wings and beats them against the ground, fanning out its tail and ruffling out its body feathers to make it appear larger. A futile threat from one so small? Not if doing so startles the grazing animal enough to deflect it from its path. Killdeers have been known to try this strategy against farm tractors, too!

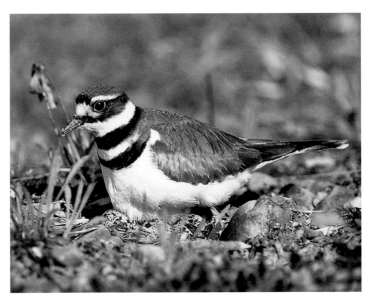

A Killdeer settles onto its eggs on the ground.

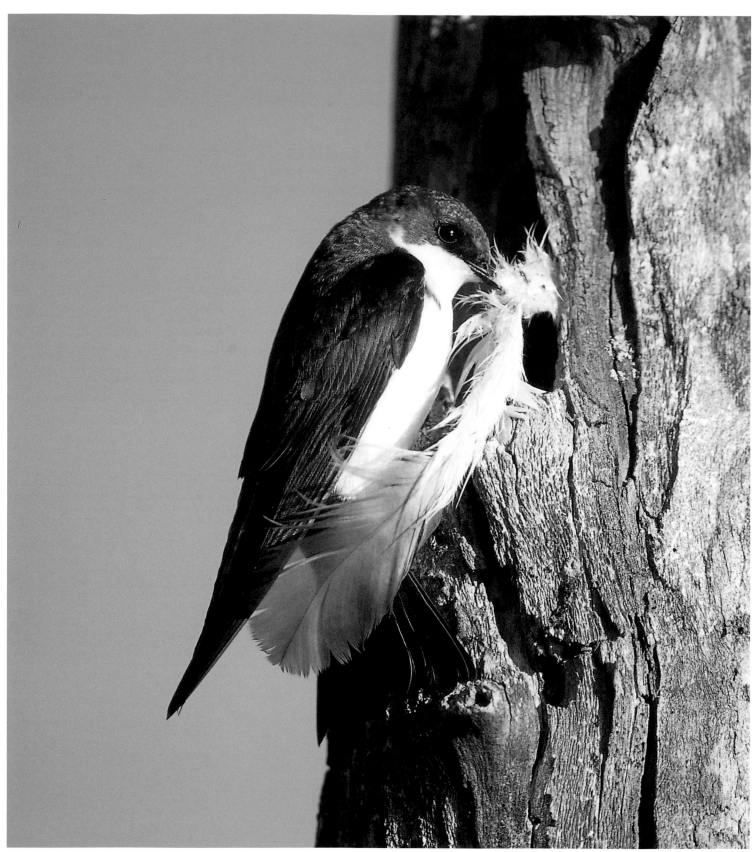

A female Tree Swallow takes a feather into her nest hole.

Feathering Her Nest

Carrying a prizewinner of a feather almost as long as she is, a female Tree Swallow is putting the final touches to her nest in a tree stump. These birds build a nest cup of dead grass in an old woodpecker hole or birdhouse, then, as a final flourish, line it with feathers.

Tree Swallows prefer the body feathers of waterfowl, gulls, and domestic poultry. The aerial acrobats swoop down to snatch up feathers floating on the surface of water, hover to pick out feathers caught in vegetation, or snag them in midair.

Competition for these treasured feathers is fierce; the feisty birds often have midair battles over them. A flying swallow carrying a feather risks being chased aggressively by more than one pursuer, each trying to steal the prize. If the feather is dropped and starts to zigzag its way slowly earthward, an aerial skirmish may take place as several swallows try to capture it at once.

Biologists have found Tree Swallow nests containing more than 100 feathers, although 30 to 40 is a more typical number. Many feathers are added to the nest after egg laying has started. Once incubation has begun, feathers are brought by the male but are put in place by the female sitting on the eggs. She carefully arranges the feathers with their quills tucked along the side of the nest and their vanes curled over to cradle their precious cargo.

Why are these feathers so important? Like a cozy down comforter, they provide much-needed insulation for the developing eggs and growing nestlings. It's particularly important for early nests when spring weather is unpredictable, or later in summer when unseasonably cold or wet conditions last for more than a few days. When the weather turns cold, wet, or windy, breeding Tree Swallows may be hard-pressed to find enough flying insects to feed themselves and their young. Sadly, this often leads them to abandon their nests.

The feather lining may also act as a barrier between the growing nestlings and harmful skin parasites, such as mites, lice, and fleas, which often lurk in birds' nests, particularly in previously used nest cavities. Biologists have discovered that nestling Tree Swallows in well-feathered nests grow faster and often have a lower skin parasite infestation than those in poorly lined nests.

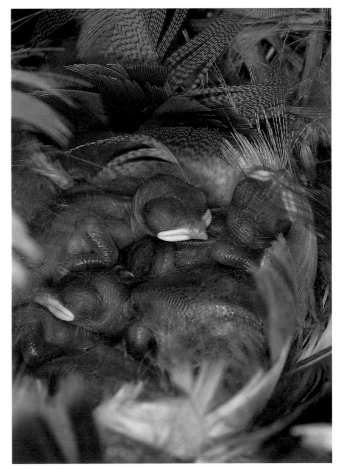

Tree Swallow nestlings snug in their feather-lined nest.

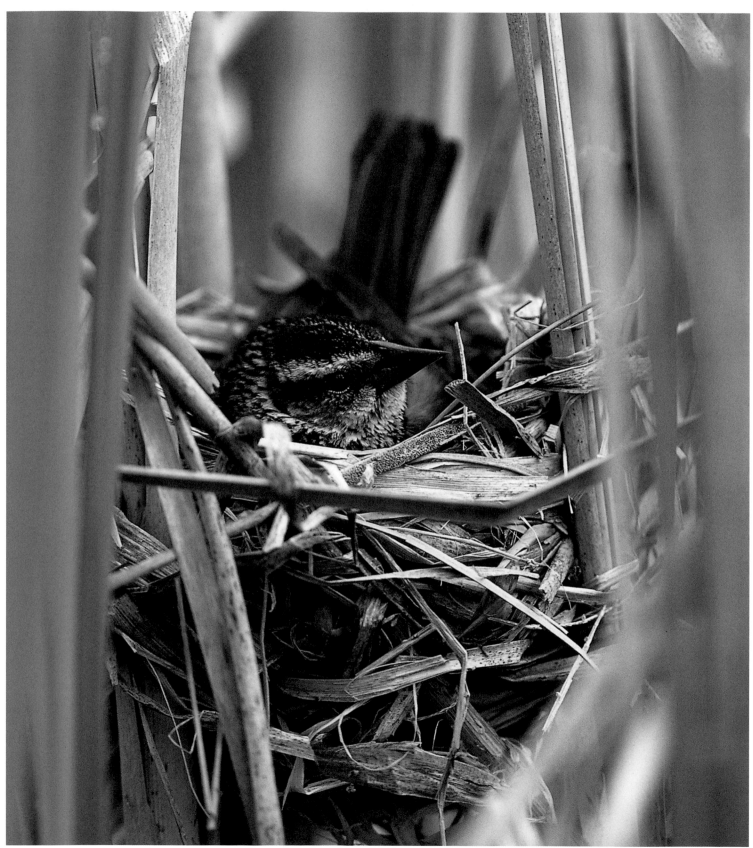

A female Red-winged Blackbird incubates in her nest hidden among the cattails.

Sitting Pretty

Settling down deep in her nest suspended from cat-tail stems in a marsh, a female Red-winged Blackbird begins the job of incubation—using her body heat to provide the warmth her eggs need to develop. Like females of other species in the blackbird family, she has sole responsibility for this task. Yet elsewhere in the world of birds, incubation is often a shared activity, done by both sexes. What could be the reason for some species' separate roles?

Plumage color may be one factor. In many birds, male and female look very different, called "sexually dimorphic" by biologists. Male orioles, warblers, cardinals, and bluebirds are brightly colored, but females are more muted. Birds often try to locate their nests in such a way as to be hidden from potential predators. A colorful male might draw attention to the nest, so it's better if he leaves the eggs in the care of the more camouflaged female. Female ducks support the plumage explanation, too. Usually much drabber than males, they incubate, and raise their young, alone.

In certain other birds, though, male and female look alike. In Killdeers and other plovers, herons, gulls, doves, and woodpeckers, the two sexes look similar to each other, even identical. And indeed in these bird groups both members of a pair share incubation duties.

Exceptions show us that plumage color is not the whole story, though. The female Red-eyed Vireo, on the right on her nest, is identical to the male, but he doesn't incubate (although males of other vireo species do). Nor do male wrens, sparrows, flycatchers, and non-passerines such as hawks and owls, whose sexes look alike. Yet the colorful male Rose-breasted Grosbeak and his cryptically plumaged brown mate *do* share incubation, one of the few dimorphic passerines to do so.

That's not to say that male birds don't play essential roles during incubation, even if the female has sole responsibility. During the long job of sitting on eggs, the female still needs food. When members of a pair share incubation, one can go off to feed while the other takes over at the nest. In species in which the female alone incubates, the female must balance the time she tends the eggs against the time she needs to feed herself.

Some ladies-in-waiting solve the problem by getting lunch delivered. The male Red-eyed Vireo shown below brings a nice fat caterpillar for his mate. Male cardinals, goldfinches, kestrels, and chickadees are just as dedicated, regularly feeding their mates on or near the nest.

Other females, for example those of Baltimore Orioles, Eastern Kingbirds, and Red-winged Blackbirds, leave the nest briefly to forage nearby when hungry. Usually their trusty males stand guard, keeping a close watch on the nest, ready to defend its precious contents against intruders until their mates return.

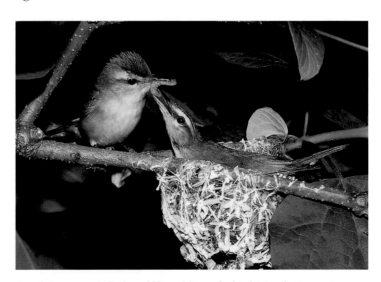

Lunch to go: a male Red-eyed Vireo delivers food to his incubating mate.

Summer
Season of Plenty

The season of growth and abundance—lavish flowers, lush greenery, growing young birds, and the insects, seeds, and fruit to feed them. Birds visit our gardens to splash in cool pools of water and ply the treetops for food. Springtime favorites that have fallen silent while nesting reappear with their begging youngsters in tow.

As summer's heat mounts, the chirring of cicadas in the trees or the lazy buzz of a fly nearby puts us in mind of a slower pace of life. But for birds this is hardly a season with less to do. Raising a brood of young from nest to independence is no easy task, yet some species try for a second or even a third family as the summer progresses.

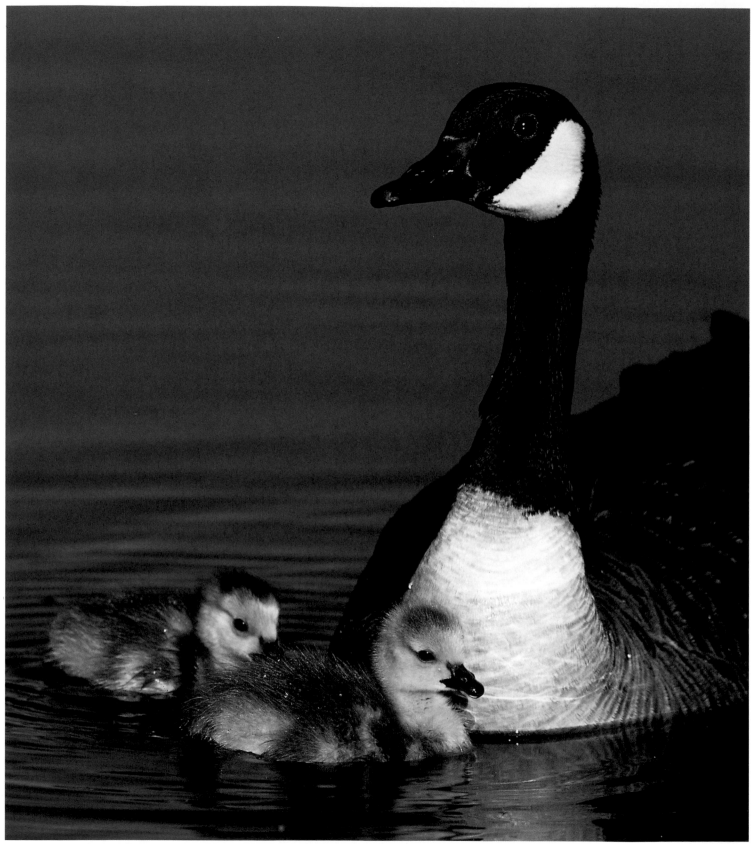

Canada Goose goslings with their parent.

New Arrivals

Everyone loves a new baby. And few babies are cuter than fluffy chicks. Golden, bright-eyed goslings, like these day-old Canada Geese, never fail to get their share of "oohs" and "aahs" from even the most jaded birders. But Chestnut-sided Warbler hatchlings, below, are naked, wobbly, and blind—faces only a mother could love! Why should baby birds look so different?

Biologists categorize young birds into two main types. At one end of the spectrum are "precocial" young: ducklings, baby shorebirds, coots, cranes, gulls, turkeys, and of course fluffy, yellow Easter egg chicks. These kids are born to run and sometimes to swim. Adorably out of proportion, they have large heads, open eyes, and big feet, and are covered with down. They can often feed themselves, although they may need to be shown what to eat at first.

Precocial young are usually also "nidifugous," meaning nest fleeing: they leave the nest at or soon after hatch. In a few precocial species though, notably the gulls, the young are "nidicolous," staying in or near the nest until they are well developed.

Much of the bird world has a very different childhood. Termed "altricial," they hatch truly as helpless as babes. In this group are herons, hawks and eagles, owls, woodpeckers, pelicans, and songbirds. To us at least, they are far less appealing, having feeble, naked, pink bodies with visible innards, skinny necks, and eyes tightly shut at first. Only able to wriggle, they're totally dependent on their parents for food. Altricial young are always nidicolous.

Predation and feeding habits determine whether a particular group of birds is precocial or altricial. Precocial species typically nest on the ground, so they are especially vulnerable to predation by mammals. Their young need to be mobile to leave the nest soon after hatch to avoid discovery. Since these chicks can feed themselves, in certain species the female can care for her numerous young alone, as do ducks, quail, and turkeys.

Altricial young avoid predation by growing up in cup nests, either hidden in dense vegetation, such as those of backyard songbirds, or sequestered in tree holes, as are woodpeckers. Altricial broods are typically smaller than those of precocial species, and usually both parents bring food for them.

Whether babies are cute and fuzzy or bare and blind, parenthood is a big investment. Precocial chicks hatch from eggs that are relatively large compared to their mother's body and that are incubated longer than those of altricial young. This means that, in energy terms, adults of precocial species invest more in their youngsters *before* they hatch. In altricial species the parents put more energy into the young *after* hatch.

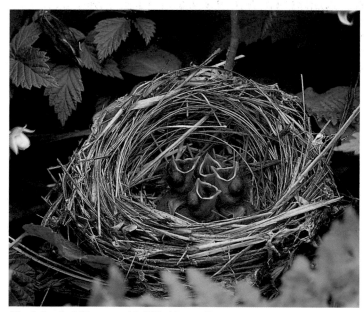

Newly hatched Chestnut-sided Warbler nestlings.

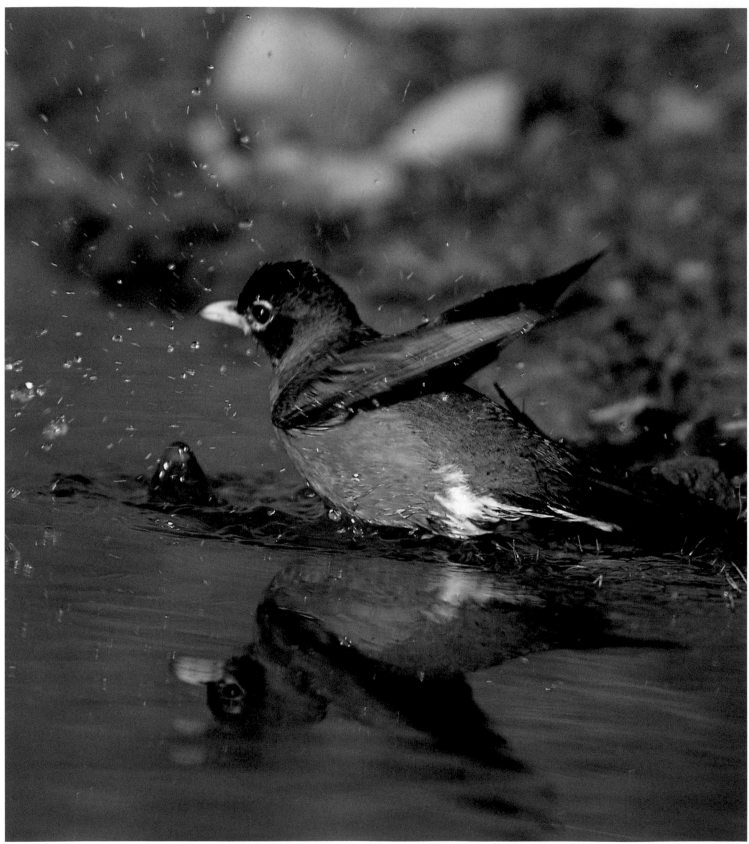

An American Robin takes a morning bath at the edge of a pond.

Bathing Beauties

It's bath time! A male American Robin enjoys a morning dip at the edge of a shallow pond. Wading belly-deep into the water, he fluffs out his feathers and dips his breast under the surface over and over again, vigorously flicking his wings to splash the water over his whole body, making the droplets fly. Thoroughly wetted, he'll shake off the water, then fly to a sheltered perch nearby for a long preening session and to dry off.

Waterfowl, such as the Green-winged Teal below, seem as enthusiastic about bathing as do land birds, despite spending so much of their lives swimming in water. Ducks and geese splash around with such vigor that sometimes they spin in circles, even rolling upside down in their attempts to wet their plumage.

All birds need to bathe regularly to keep their feathers clean and in good condition. They bathe more often in hot weather, evidence that it helps them cool off, too. Anywhere there's standing water will do. Dew or rain-drops accumulated in the hollow of a leaf can provide a bath for tiny warblers.

Swallows and swifts, which rarely land on the ground, bathe by quickly dipping into the water as they swoop low over a pond or lake, then shaking off the water drops as they fly. Woodpeckers and nuthatches bathe more passively, by spreading their wings and tails during a rain shower.

Ever heard of "dry shampoo"? Birds invented it first! If there's no standing water available, birds dust-bathe. Lolling on a patch of dusty ground, they shuffle around, rubbing themselves in the dust and tossing it over their bodies by fluttering their wings, then shaking it off.

Providing a water source is one of the best ways to attract birds to your yard, especially in summer or if you live in a hot climate. A backyard pond or birdbath (especially if it has moving or dripping water) acts like a bird magnet. They'll even use a lawn sprinkler just like a shower.

For birds, bathing is often a social activity: once one gets going, others join in, too. Be sure to provide some safe shrubbery where they can perch to get dry; wet feathers temporarily interfere with flight, leaving birds vulnerable to predation.

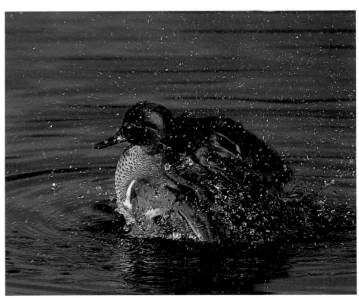

A male Green-winged Teal enjoys a splash.

A thirsty House Finch takes a welcome drink from a shallow pool of water. It does so one drop at a time, repeatedly dipping its bill into the water, then tipping it upward so the water flows down its throat.

Like all living things, birds need water to survive. They must replace the water they lose by evaporation during breathing and in their droppings. In hot, dry conditions the need is even more critical. Size matters too: smaller, more active birds lose water faster than larger species, because of their relatively large surface to volume ratio.

Regardless of bill shape, most birds, from ducks to ibis to small songbirds, drink using the same dip and tip method as the House Finch. Doves and pigeons are among the very few birds that can actively suck up water. The Mourning Dove, below, places its bill under the water's surface and, using a muscular pumping mechanism in its throat, draws the liquid into its bill until its thirst is quenched.

Pond edges, stream banks, rain puddles, and even suburban gutters and downspouts attract their share of birds to drink. Tiny warblers can drink from dewdrops or raindrops on leaves. Swallows drink on the wing, swooping down to skim the water's surface with open bills. Finding water in winter has its own challenges, as we will see later.

Most species need to drink freestanding water regularly, especially if, like finches and doves, they eat a lot of dry seeds. But birds also can obtain water from food, particularly if their diet includes many juicy fruits and soft-bodied insects.

In fact, certain well-known birds seem not to drink at all: drinking has yet to be observed in insect-eating Eastern Phoebes and Great Crested Flycatchers. Not surprisingly, hummingbirds don't drink either; they undoubtedly get plenty of water from the nectar they feed on. Cedar Waxwings seldom drink water, taking a sip only in winter when their main foods— juicy, high-sugar-content berries—have become dry and shriveled.

Birds also can manufacture some of the water they need during the chemical breakdown of food. Known as metabolic water, this allows some desert-dwelling birds to survive long periods without actively drinking.

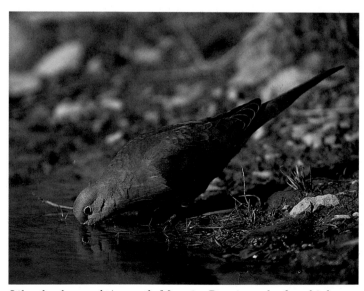

Like other doves and pigeons, the Mourning Dove is a sucker for a drink.

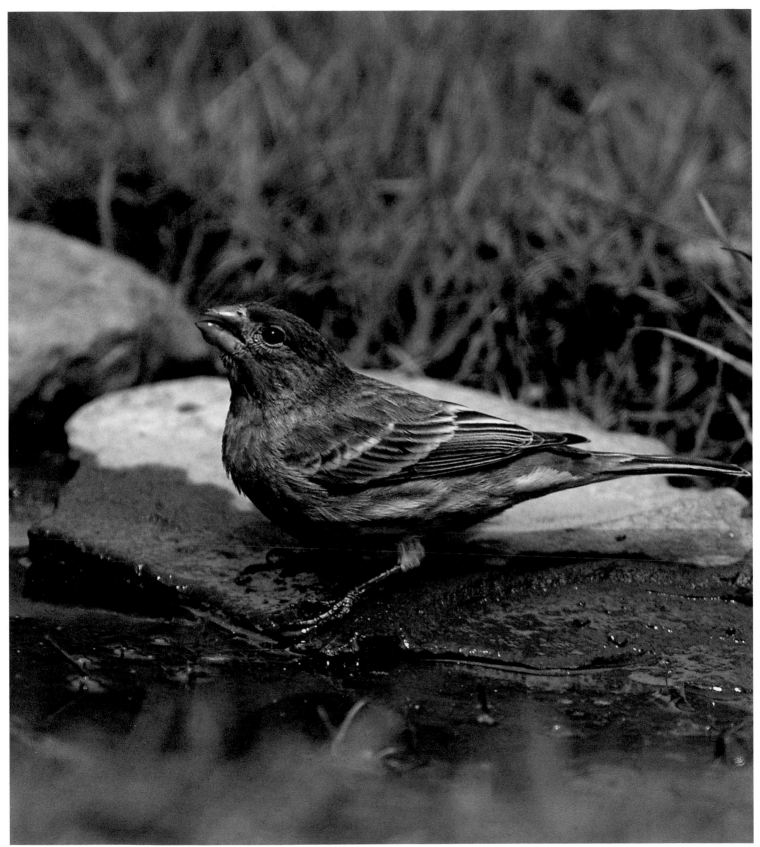

The pause that refreshes: a male House Finch sips from a puddle.

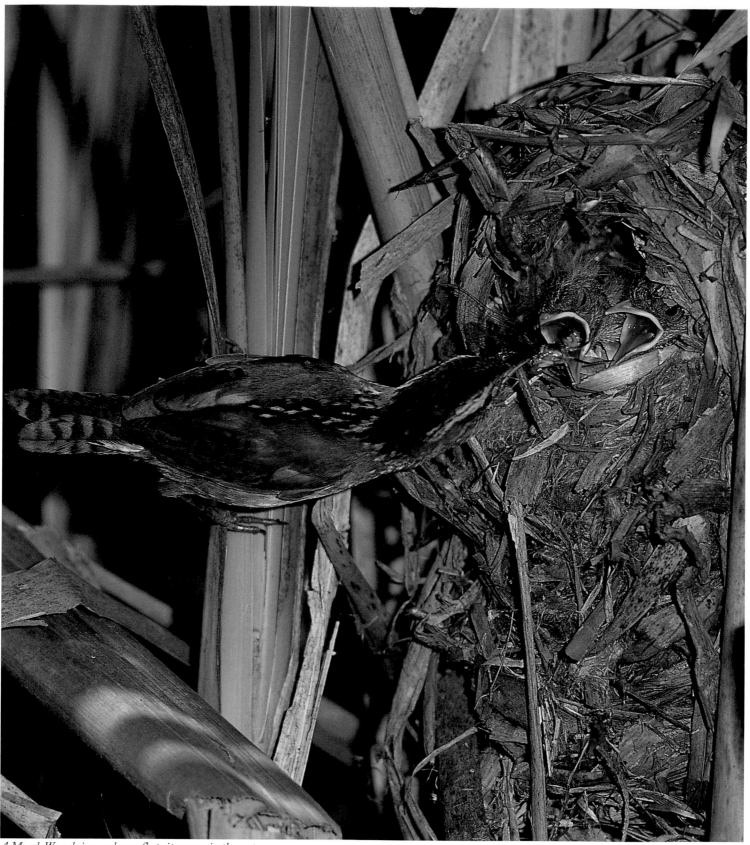

A Marsh Wren brings a dragonfly to its young in the nest.

Supersize Me!

A Marsh Wren brings a big dragonfly to its nest and one lucky nestling will get the juicy insect all to itself.

Bird parents are skilled at judging the portion size their youngsters can handle. At first, the adult wrens bring small gnats and mosquitoes for each tiny hatchling. As the young grow, the portions get larger and larger. On the menu for these nestlings were beetles, caterpillars, spiders, damselfly nymphs, and, eventually, supersize dragonflies complete with wings.

Most songbirds, even seedeaters, feed their young insects and other invertebrates. Growing nestlings need animal-based protein, and lots of it, to develop best. Small songbirds such as wrens, chickadees, and warblers carry one prey item at a time in their bill, working hard to raise their families. Female Marsh Wrens bring food as often as every ten minutes when their young are near fledging age. Beginning at first light and ending some fifteen hours later in midsummer, they feed well over a hundred times a day.

New hatchlings beg only weakly, reaching up silently with open mouths. Mouth linings are often red, orange, or yellow, and sometimes patterned. The bright color acts as a kind of "put food here" signal for the parents. The adult stuffs food into the nearest gaping bill and heads off for more. As the hungry nestlings get bigger, though, they beg aggressively and noisily, vying with each other over who will be fed first.

Certain birds regurgitate food to their young. Herons and gulls swallow fish and other food items, returning to their nests with full stomachs or throats. Urged on by their nestlings' begging, they go through a series of gagging movements and bring up the food into the nest where the young seize it immediately, often fighting with others to do so. It's not a pretty sight!

Older altricial youngsters may be so impatient that they take the self-service route. Famished young Double-crested Cormorants, below, fling themselves at their returning parent. The winner plunges its entire head into the adult's open bill to reach the fish in the adult's throat, while its siblings must wait their turn.

So much for table manners.

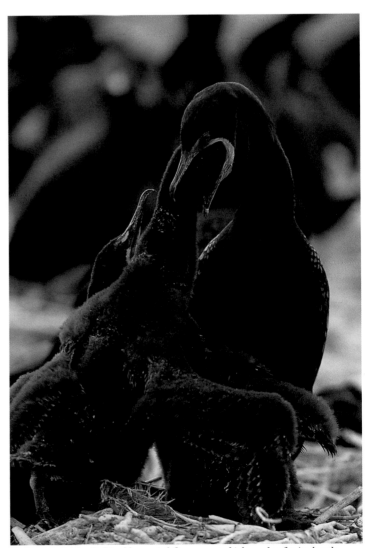

An overenthusiastic Double-crested Cormorant chick reaches for its lunch.

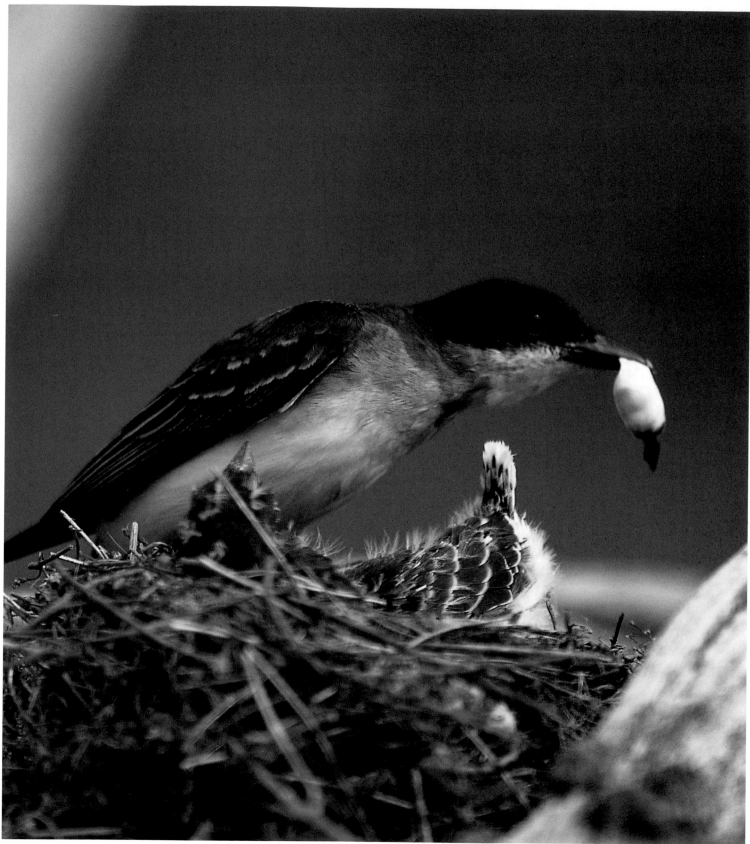

An Eastern Kingbird removes a fecal sac from a youngster's upturned rear.

Diaper Service

What goes in must come out. And any parent knows it can be messy. But certain birds, notably songbirds and woodpeckers, have a handy way to dispose of their youngsters' waste material. Their nestlings produce droppings neatly prepackaged in a membranous bag called a fecal sac.

Without some kind of sanitation behavior, droppings would accumulate, soiling the nest and exposing nestlings to pests or disease. Plus, being light-colored, bird droppings left in the nest might attract the attention of predators. So it's to the parents' advantage to remove the droppings as soon as possible.

After a parent songbird feeds its young, it usually watches intently to see if a fecal sac is going to be produced. The parent immediately picks up this convenient little parcel in its bill, as this Eastern Kingbird is doing, and flies off with it, dropping it some distance from the nest.

But sometimes the adult birds get rid of the fecal sacs another way—by immediately swallowing them. It sounds disgusting, but by eating its youngsters' droppings the adult can obtain useful nutrients that would otherwise be thrown out. Usually this happens only early in the nestling period—later, as the young birds approach fledging age, the parents tend to carry fecal sacs off and discard them. Biologists suggest this is because a newly hatched nestling's digestive system is not yet mature, so its droppings contain nutrients that the young bird can't yet absorb. As the youngster grows older, its intestinal tract digests more effectively, so there are fewer valuable nutrients to justify the parents' recycling the droppings.

Diaper service isn't available to all birds. For birds whose young leave the nest soon after hatching—ducks and shorebirds, for example—waste accumulation isn't an issue. Nestlings of some birds that remain in the nest—baby herons and birds of prey, for instance—don't produce fecal sacs either. They simply back up to the edges of the nest and squirt their feces over the edge.

Watch out below!

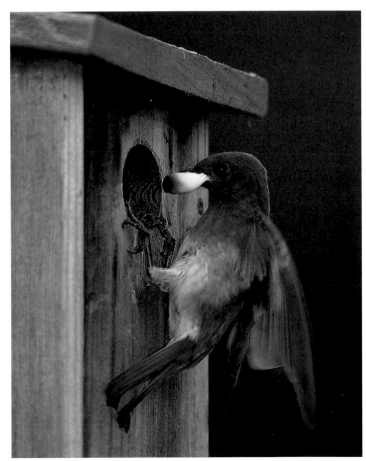

A male Eastern Bluebird takes a fecal sac away from its nest box.

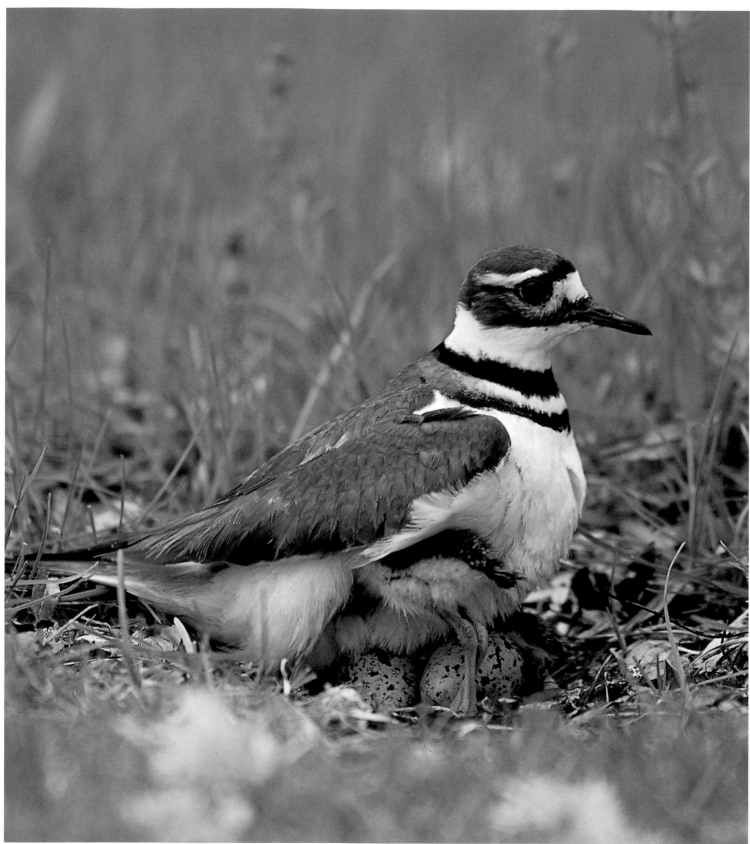

A Killdeer chick snuggles into mom's feathers on a cool morning.

It looks like a Killdeer's version of hiding your head in the sand: a baby buries its head into its parent's feathers, eventually snuggling so close that only its legs are visible. Is the tiny Killdeer on the left trying to avoid reality? No, it's just keeping warm.

Despite emerging from the egg down-covered and lively, newly hatched shorebirds, gulls, turkeys, and cranes lack an efficient thermoregulatory system at first. Until their body's physiology matures, allowing these precocial youngsters to regulate their own body temperature, they need to be brooded by their parents for warmth. Altricial nestlings, which lack any insulation at hatch, need this shelter even longer.

Two more eggs and a second chick, still wet from hatching, are partly hidden beneath this mother Killdeer. She broods constantly until the remaining eggs hatch and the chicks have dried off, before leading the whole family away to a feeding area. The tiny fluffball youngsters can feed themselves immediately, but they scurry to their parents to be brooded between snacks, or anytime during cool or rainy weather.

As the chicks warm up, they wriggle and free themselves from the adult's embrace, wandering off to feed again, with the adults following them. The youngsters grow fast, and within a few days they're better able to keep themselves warm, so they are brooded less often.

The Eastern Kingbird on the right has the opposite problem: her young are getting too hot. Panting in the intense noontime heat of midsummer, she spreads her wings over her vulnerable nestlings, using her body to shade them and keep them from overheating.

Eastern Kingbirds are renowned for being vigilant and aggressive while breeding. They sometimes nest in an open place such as the top of a stump or snag, or on a bare branch over water. Isolating the nest in this way lets the pair more easily notice predators and drive them off. It comes at a price, though. The nest is exposed to the elements—wind, rain, and especially sun. Overexposure to the sun's heat can be lethal to nestlings of any species, and particularly dangerous to those that nest in the open. Birds from terns to herons to robins shade their young when necessary.

Only the female kingbird performs shading behavior. On clear, sunny days in particular she spends much of her time standing on the nest sheltering the young, even when, like these, they are almost old enough to fledge. Yet time spent shading is time taken away from searching for food for the youngsters. It's just one of the many tradeoffs parent birds make on a daily basis while they raise a family.

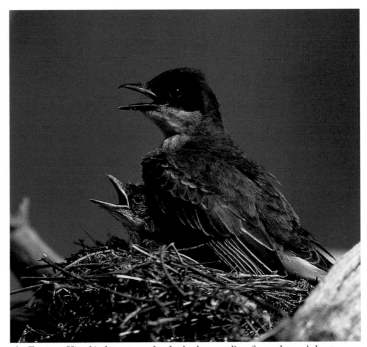

An Eastern Kingbird pants as she shades her nestling from the sun's heat.

On a late June morning, the first two of a quartet of young Baltimore Orioles make their way out into the world. For two weeks they've been rocked in their cradle high in a cottonwood tree, but the growing babies soon find their basketlike nest too cramped.

One day the oldest starts exploring, scrambling up the sides of the nest to take its first peek at the outside world. Next day it finally clambers out completely, first onto the nest rim, then onto the surrounding branches. Cautiously, its brothers and sisters follow, each making the rite of passage from nestling to fledgling. Despite being wobbly, with short tails and stubby wings, they grip the branches safely with strong legs and feet.

Many people think that the term "fledge" means birds actually fly away from the nest. It's often not so; young birds vary widely in when they make that maiden flight. Like the orioles, fledgling Cedar Waxwings, below, climb out of their nests at two weeks old. Only able to fly clumsily for short distances, they stay near the nest under cover for several days while the adults

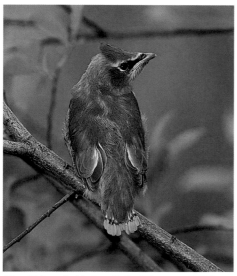

New kid on the block: a Cedar Waxwing fledgling.

continue to feed them. Ground-nesting songbirds leave home even earlier. Bobolink young leave the nest just ten days after hatching. Unable to fly at all, they hide in the tall grass nearby until their flight feathers have finished growing and they are stronger.

At the other extreme are the swallows, which live life on the wing. Their young may spend nearly three weeks in the nest, longer than most songbirds, and they can fly fairly strongly on well-grown wings as soon as they leave. Hole-nesting bluebirds and chickadees have little choice but to fly to leave their nests, but they can only flutter a short way at first.

Why leave the nest if you can't fly well? The reason is that a nest of noisy baby birds is not a safe, cozy home but a rather vulnerable place. A prowling raccoon or squirrel that finds the nest will eat not just one nestling but the whole lot, and the adults' efforts will have been for naught. Dispersing the young ones in nearby vegetation, though, lessens the chance that any one of them will be discovered. So parent birds work hard to raise their young and get them away from the nest as soon as possible.

Another misconception is that adult birds teach their young to fly. Flight is an inborn skill; young birds don't have to learn how. They do need to practice and strengthen their muscles, though, by flapping their wings vigorously while still in the nest.

If you find a young bird on the ground apparently unable to fly, don't assume it's abandoned and needs your help. Instead place it carefully in the nearest leafy shrub or tree out of harm's way. Then leave it alone; its parents will find it. Keep your pets indoors. Soon the young family will be on its way.

They're leaving home . . . bye-bye!

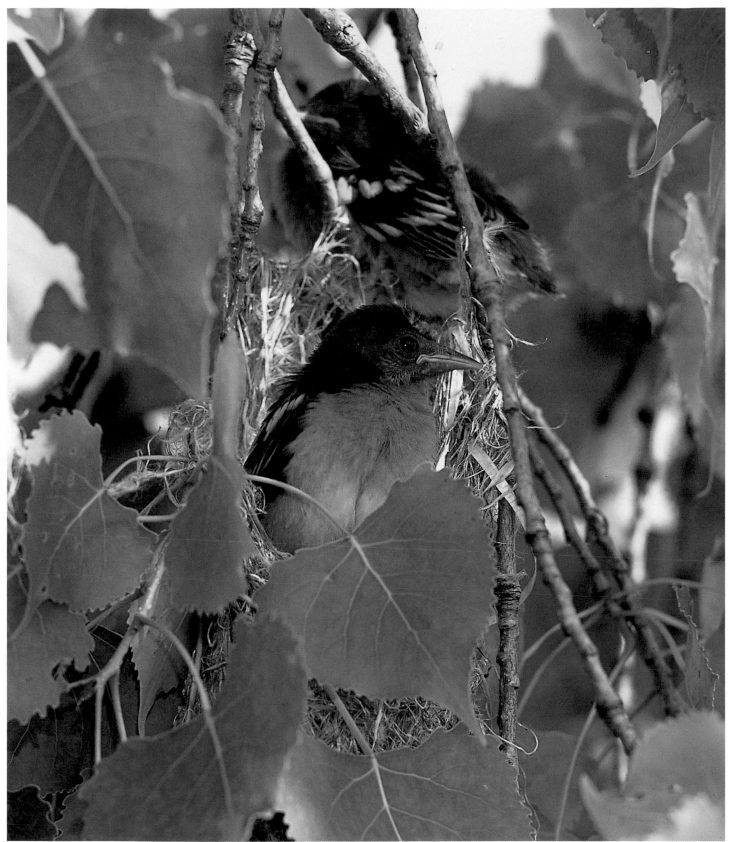

Out into the world: Baltimore Oriole fledglings leave their nest.

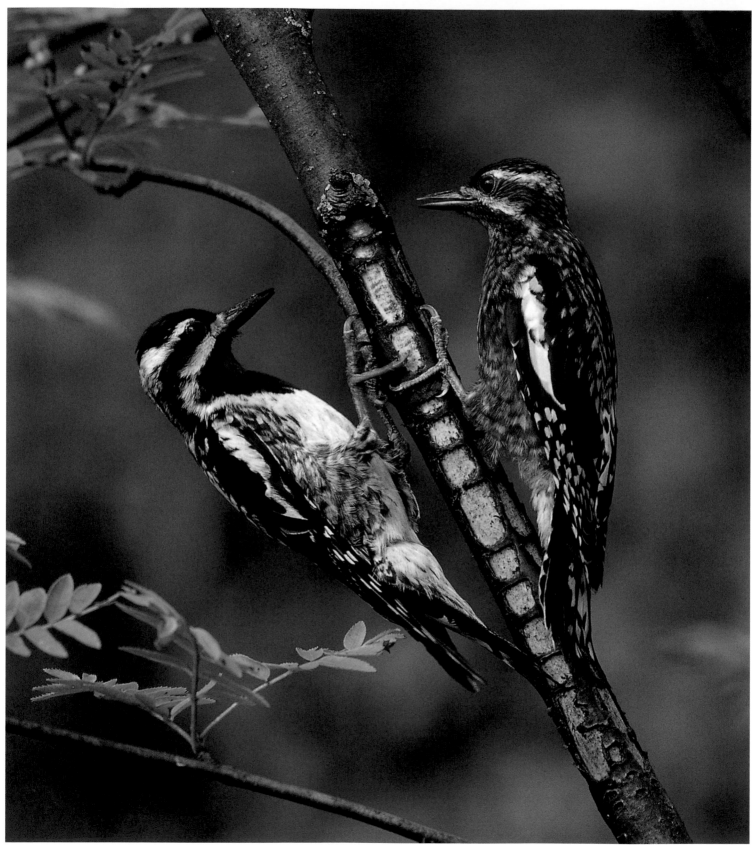

A Yellow-bellied Sapsucker fledgling (right) accompanies its father to sap wells.

Until now, this Yellow-bellied Sapsucker fledgling led a sheltered life, sitting in a hole in a tree, relying totally on its parents for food. Nearly a month old, it finally has come out into the world, taking its first steps toward self-reliance. It's joined its strikingly colorful father to feed from the sap wells the adult has made.

Typical woodpeckers dig for woodboring insects. Sapsuckers, though, are named for their habit of feeding on the sap that flows from shallow holes they drill in tree bark. They also catch insects lured to the sweet, nutritious liquid. They prefer trees with thin, smooth bark for feeding. To keep the sap flowing, they work on their sap wells regularly so, like these, drillings that start out round become rectangular.

Watching young birds growing up, we may wonder whether their foraging behavior is innate or whether they must learn to feed themselves. The answer is probably both: nature and nurture each play an important role.

One issue is how well developed a particular species is at hatch. Young waterfowl, which hatch down-covered and active, can feed themselves immediately. Fluffy Wild Turkey and Killdeer hatchlings must be shown the correct food types by their parents, but they can pick up the food themselves. Woodpeckers and songbirds, though, hatch naked, blind, and helpless, and are fed by their parents even after leaving the nest.

Tapping on wood is something every woodpecker is born to do. Even so, for a sapsucker, feeding methods need a bit of fine-tuning. Fledgling sapsuckers stay with their parents for several weeks. For the first few days, the adults continue bringing them insects. Eventually the young follow the adults to their sap wells.

Soon the parents begin ignoring their youngsters' begging, and the young birds start drinking the sap themselves and catching the insects attracted to it.

Finally the fledglings start trying to drill their own wells. At first their success is hit or miss: sometimes they mistakenly choose dead wood or trees with bark that's too thick. Six weeks or so after leaving the nest, they've got the technique down.

Songbird fledglings are curious and automatically peck at and pick up objects with their bills. They learn appropriate food choices while watching their parents forage. Nonetheless, they're often in no hurry to look after themselves: the young Northern Cardinal below is still begging from its father, even though its adult-length tail tells us it left the nest two weeks ago. Harried parents eventually may resort to tough-love tactics, in the form of aggression, to force their pesky offspring to feed themselves, particularly if there's a second family on the way.

Time to fend for yourself, kid!

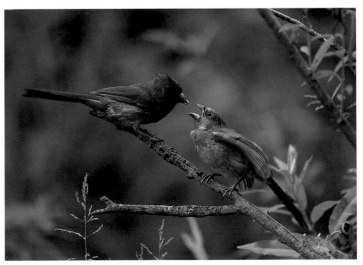

A Northern Cardinal fledgling (right) begs for food from its father.

Late Bloomers

It's mid-July and the heat is on. Many songbird youngsters, as well as fledgling woodpeckers, birds of prey, and various other birds, left the nest long ago and are noisily following their parents around woods, marshes, and meadows. Multibrooded species have started their second or even third family of the year.

For the American Goldfinch, though, nesting is only just getting started. Perched on a spent thistle flower, the olive-brown female gathers a beakful of thistle-down (the fluffy part of wind-borne thistle seeds) as material for her nest. Her colorful mate, seen in the background, accompanies her closely, flying to and from the nest with her as she builds.

Goldfinch courtship actually begins much earlier in the year, when our gardens are suddenly filled with tinkling, golden flocks heralding the approaching spring. The males' merry, jingling songs more than compensate for their motley scruffiness while they change from muted winter plumage into characteristic bright yellow breeding dress.

Singing loudly and chasing each other around, they seem as keen to start nesting as all the other spring songsters. Some pairs may indeed form during these prebreeding flocks, but then the spring courtship behavior subsides, only to resume again later in the summer. This time it's in earnest.

Why does the goldfinch get such a late start? Biologists believe the bird's nesting is timed to coincide with the flowering of its primary source of nest material and nestling food: composite plants, such as the daisy relatives and, in particular, thistles.

The American Goldfinch's diet is made up almost entirely of seeds year round. It even feeds seeds to its young, regurgitating a slurry of partially digested seeds into each nestling's open beak. Most other seed-eating songbirds alter their foraging habits while breeding to feed their youngsters insects, ensuring the young get the protein they need to grow up strong. Goldfinch young, though, manage to thrive on seeds as their sole protein source.

With some nests begun as late as August, goldfinch youngsters may not leave the nest until October. As the colorful flowers of late summer wither, throngs of goldfinch fledglings will enjoy nature's rich bounty of ripening seeds, recycling summer's fading golden hues into the gilded songsters of next year's spring.

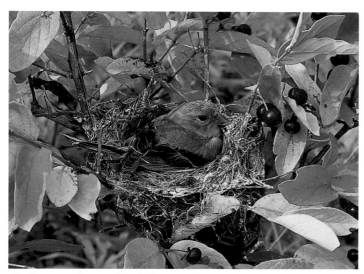

Amid summer fruits, a female American Goldfinch incubates her eggs.

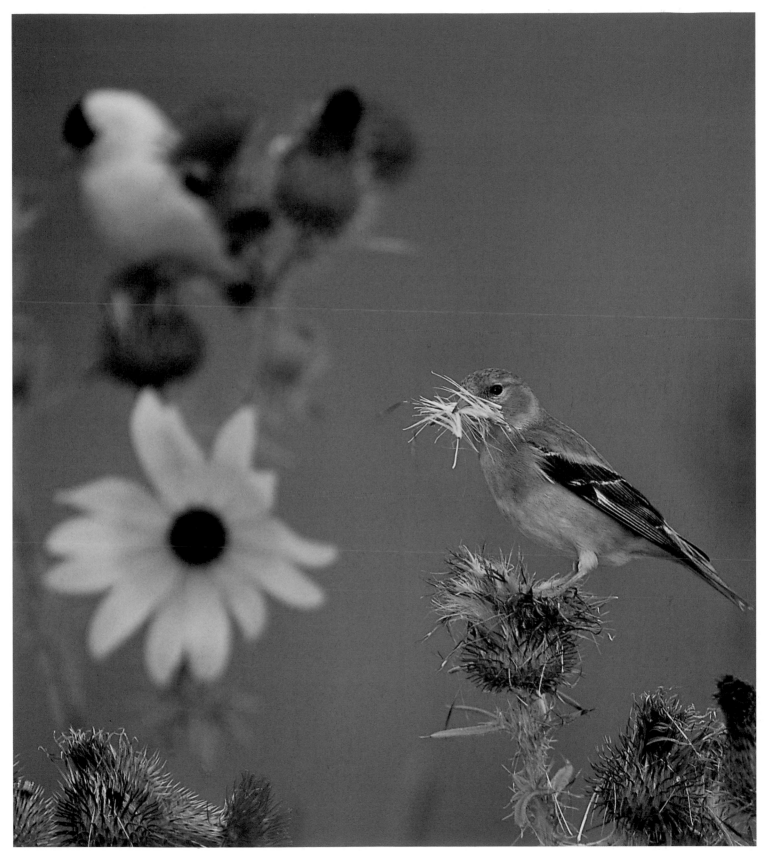

Accompanied by her mate, a female American Goldfinch gathers nest material.

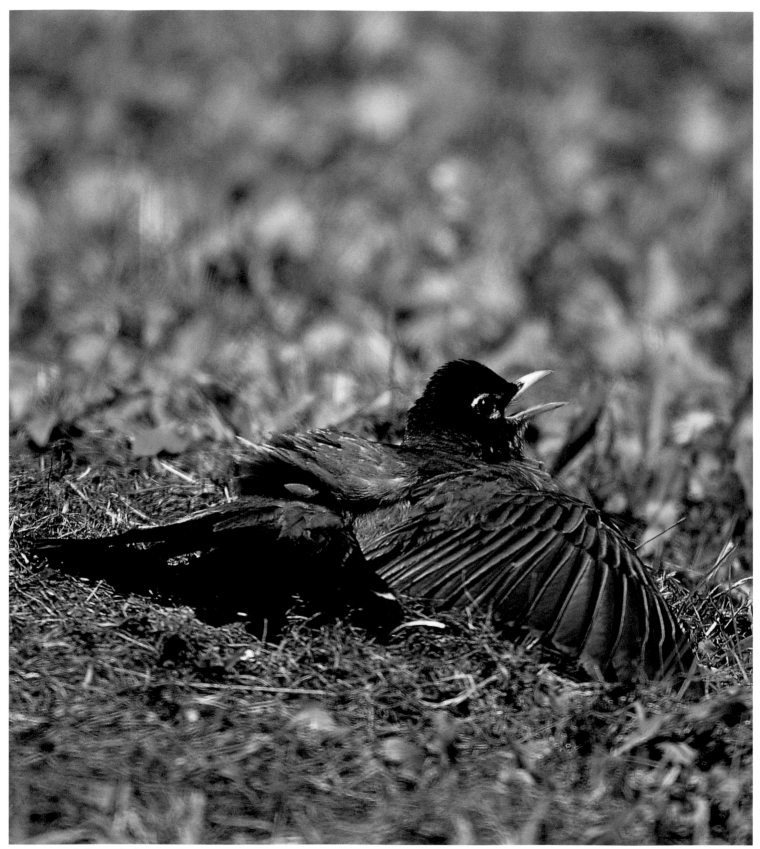

An American Robin sunbathing on a hot summer day.

Catching Some Rays

Summertime. Blue skies and warm sunshine turn our thoughts to the beach, ice cream, and sun worshippers on beach-towels. Birds, too, love to sun themselves, and while doing so they get into some bizarre poses. Spread-eagled on the ground, an American Robin basks with wings outstretched, back plumage ruffled, and tail feathers spread. As the rays beat down, its eyes flicker closed and it becomes completely motionless, bill agape, apparently in a daze. Finally, recovering its composure, it gets up and preens intensely.

Most species of birds enjoy sunbathing occasionally. Small, active species may hesitate just a few seconds in the sun; larger species may bask for minutes at a time. Finches, cardinals, and flycatchers sit on a perch or lie on the ground with ruffled feathers, leaning away from the sun to increase the surface area exposed to its warmth, often with bills open wide and an expression of apparent ecstasy! Sunbathing herons and storks hold their wings outstretched. Some birds, such as the Mourning Dove on the right, raise one wing at a time, letting the sun's warmth play upon the normally hidden underwing plumage.

Theories abound about why birds sunbathe, but few experiments have been done to explain it. Certainly sunning helps birds warm up. In winter, hawks and jays head to the treetops to catch the rising sun's first rays. Cool spring mornings find herons standing in sheltered, sunny spots in cattail marshes, banishing the night's chill. Yet, in the midst of summer, birds often sunbathe in the midday heat when we might expect them to want to stay cool. This suggests that sunbathing has another function.

One theory is that sunning keeps birds' feathers or skin supple and in good condition. Other ideas focus more on the parasites—fleas, lice, ticks, mites, and certain flies—that birds unwittingly support on their plumage. Maybe the sun's heat makes those irritating skin parasites move, loosening their hold on the feathers, so the bird can preen them off more easily. Perhaps sunlight soothes the skin irritations the parasites cause. Or maybe sunbathing simply feels good to birds, just as it does to us!

Anting is another bizarre activity. Sometimes a bird will squat down on an ants' nest, letting the insects scurry through its plumage. It may even pick up an ant and rub it on its feathers. One explanation is that the bird is using chemicals released by the alarmed ants to help control feather parasites. Biologists also are exploring whether such insect secretions help protect against fungal or bacterial damage to the feathers.

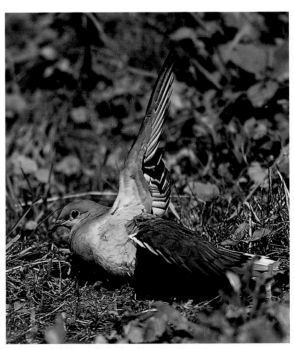

A Mourning Dove basks in the sun's warmth.

Autumn

Season of Transition

Change is in the air. Dramatic weather and crisp mornings stir a sudden restlessness in the birds of our favorite haunts. In northern regions, where the cooler weather heralds winter's approach, many insectivorous species prepare to move south. Other birds change diet or gather stores for the winter.

Migrants from the boreal forests of Canada come winging through on their long migrations to Central and South America. The honking of Canada Geese crossing the sky in V-shaped skeins sends a thrill tinged with sadness through us, feeling glad for our gloves.

Farther south, where winters are mild, the north's loss is our gain. We welcome back the northern breeders to our feeders, woodlots, and fields. Marshy areas fill with wintering swallows and the bays and inlets offer shelter to hordes of geese and ducks.

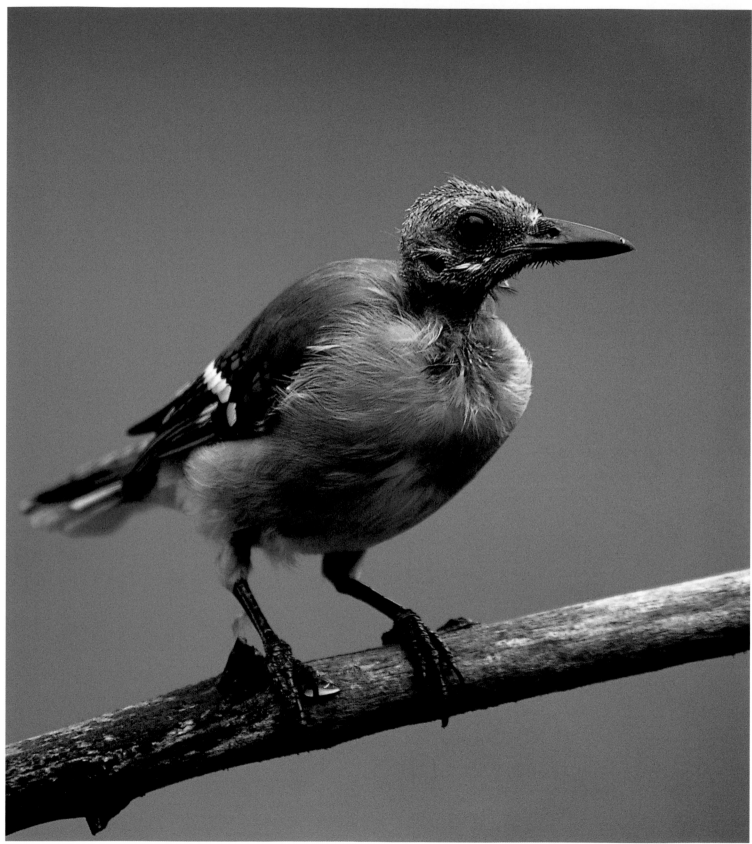

A Blue Jay sports a skinhead hairdo.

Bad Hair Day

Early autumn always ushers in a change of wardrobe for birds. Something has gone sadly awry for this Blue Jay, though; it looks like the "before" commercial for a hair-restoration treatment! All its head feathers have fallen out at once. Baldness, while unusual, is particularly obvious in Blue Jays and Northern Cardinals, birds known for their handsome crests.

Molting is normally not this drastic, of course. It's a normal event that birds go through every year, sometimes more than once. And although it's not behavior, we include it here since it's such an important and regular part of every bird's life.

Growing a new set of feathers is energy consuming, so birds do it when reproduction is no longer a priority. New feathers developing in the bird's skin follicles gradually push out the old ones. Generally, only a few feathers are lost at a time, particularly so for wing and tail feathers so that flight is not impaired.

Patterns of molting vary. Some birds undergo a complete molt in fall into a muted nonbreeding plumage, followed by a partial molt in spring, replacing only their body feathers and attaining their breeding colors once more. Handsome male Rose-breasted Grosbeaks are a good example. They look shabby by late summer, but soon they will change in appearance almost entirely. Their new winter feathers have buff tips and their breast feathers lack the vivid pink of spring. Now resembling their muted brown-streaked mates, the males spend winter in camouflaged garb.

Other species molt but once annually; jays and cardinals molt into essentially the same colors they wear all year. Fall-plumaged cardinals appear more muted especially on their backs, because, like the grosbeak, their new feathers have dull-colored tips. By early spring, the outer edges of the feather have worn away to reveal the cardinal's distinctive bright color.

Birds molt because feathers are dead structures that wear out with time and can't function correctly. Tattered or broken wing and tail feathers jeopardize efficient flight. Frayed body feathers no longer provide adequate insulation.

What about those bald birds? It's still unclear why avian baldness occurs. One suggestion is that the victim is badly infested with mites, lice, or other feather parasites, or is otherwise diseased. Alternatively, environmental or nutritional factors may be to blame. Whatever the explanation, the skinheads usually recover a full head of feathers in time.

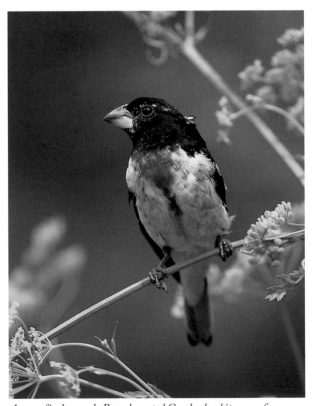

August finds a male Rose-breasted Grosbeak a bit worse for wear.

Can't Believe He Ate the Whole Thing!

A hungry Cedar Waxwing gulps down a ripe crab apple in autumn. By swallowing berries and other small fruits whole, and later passing the seeds out in their droppings in another location, waxwings are important dispersers for fruit-bearing plants. Robins, bluebirds, catbirds, and vireos eat berries whole in the same way. Cardinals and grosbeaks eat fruit too, but they go for the seeds inside, discarding the pulp and cracking the hard seeds with their stout bills.

Cedar Waxwings rely heavily on fruit for much of the year, although they also catch flying insects in warm weather. They spend fall and winter in large flocks, roaming widely in search of berry-laden deciduous trees and soft-fruited conifers, such as red cedars and junipers. Finding a fruit bonanza, they descend en masse, and can strip the tree of fruit in a couple of days before moving on to find another.

Fruit even plays a role in waxwing social life: courting waxwings perform a ritual in which they repeatedly pass a berry back and forth to each other before one finally eats it.

Biologists recently discovered evidence that the saying "You are what you eat" fits the Cedar Waxwing perfectly. A waxwing feeding on the fruit of certain introduced honeysuckles, while growing its new tail feathers in fall, will form a waxy tail tip that is orange in color instead of the typical yellow. A carotenoid pigment (part of the chemical group that includes carotene, which gives carrots their orange color) in the honeysuckle berries is responsible for the color change.

The red waxy droplets on the wing feathers, which give waxwings their name, are also colored by carotenoids, but they appear not to be affected by the alien honeysuckles. These waxy wingtips vary in number and size, being most obvious on waxwings more than two years old. It's thought they signal social status as well as age, allowing individuals to evaluate each other during pair formation.

Fruit can sometimes make waxwings tipsy. Berries that stay on shrubs through the winter may ferment, forming alcohol in the fruit's juicy flesh. Waxwings that gorge on fermented fruit in late winter occasionally get so inebriated they fall disoriented to the ground. One of the perils of eating dessert first!

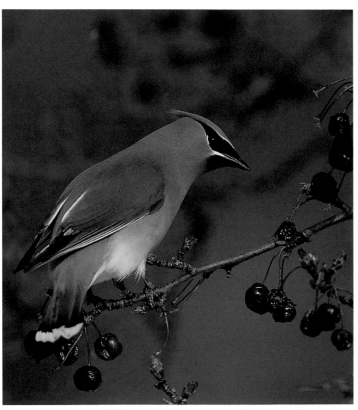

Will these go to my head? A Cedar Waxwing contemplates winter fruit.

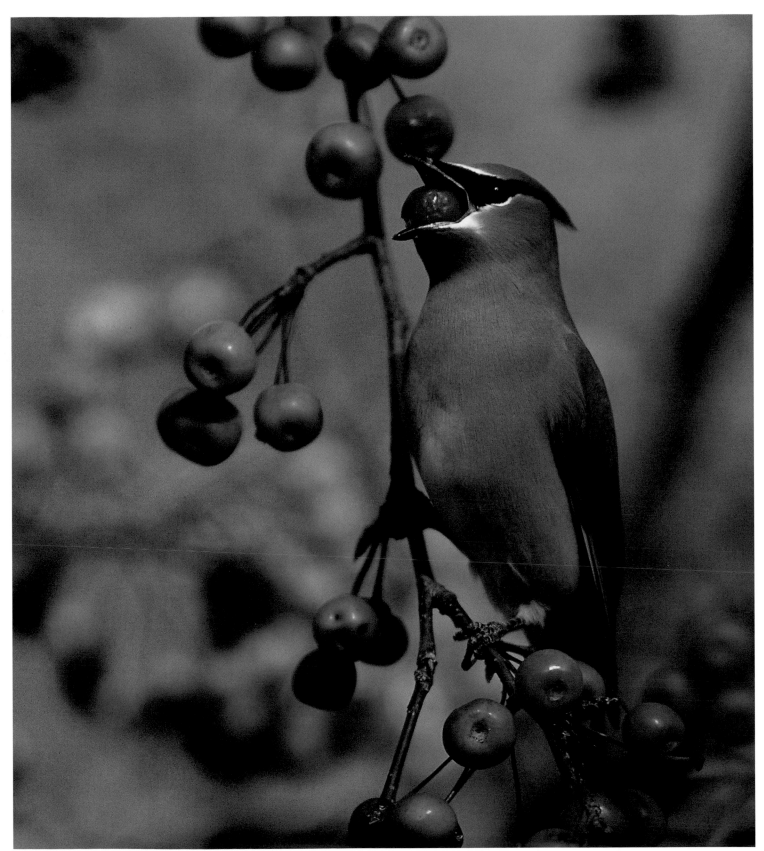

A Cedar Waxwing swallows a whole crabapple fruit.

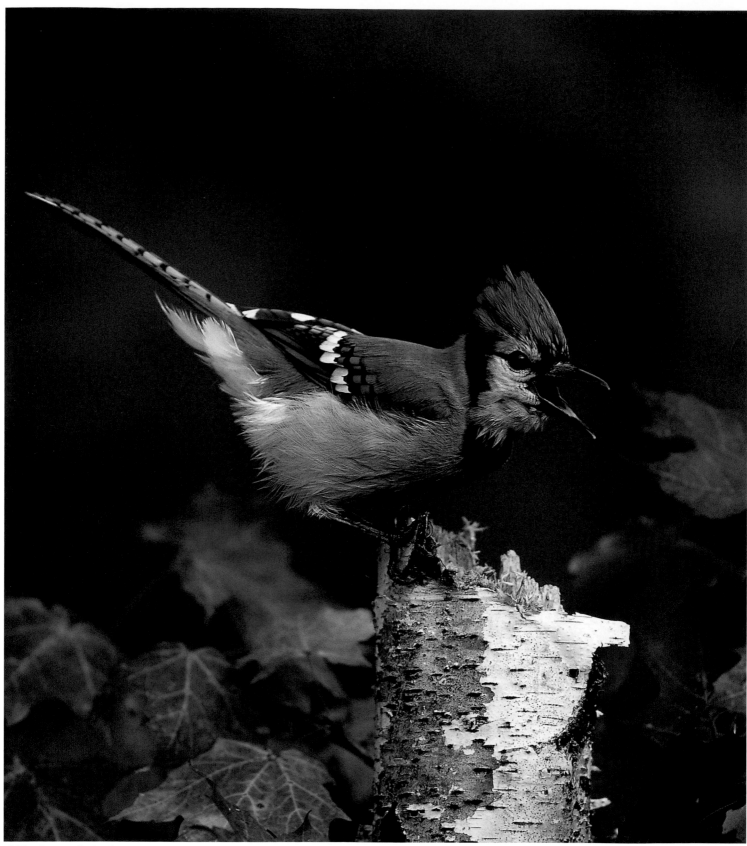

A Blue Jay sounds the alarm.

*A*larmists and Impersonators

Sentinel of the forest, the Blue Jay is a bird of many voices. Most familiar is the call for which it's named: a harsh, jeering *jaay . . . jaay* that rings loudly through the woods. Far from musical, it nonetheless is a welcome reminder that some bird life still remains when the leafless forests fall silent in autumn and winter.

The jay's raucous call is often used in alarm to rally nearby jays so that, as a group, they can mob (or harass) an intruding predator. Other birds, such as chickadees and titmice, notice jay calls too, often joining the crowd to express their discontent. If you come across an agitated group of jays and other birds calling intensely, look around carefully. You may see the object of their attention: a hawk or owl.

The Blue Jay's songbook is filled with bizarre sounds: melodious bell-like clangs, squeaky calls like a rusty gate, and an assortment of unbirdlike clicks and rattles. It's also a renowned vocal mimic, with the uncanny ability to imitate hawk calls, particularly the shrill screams of Red-tailed or Red-shouldered Hawks. Does the jay do this to warn that a hawk is nearby? Is it trying to fool other birds, scaring them away from a desirable food item? Or is there some other reason? Vocal mimicry has long been one of ornithology's most compelling puzzles.

The bird world boasts many vocal mimics. Mockingbirds and starlings are particularly talented. The European Starling convincingly imitates many other species' sounds, ranging from the Killdeer's plaintive cries to the songs of Northern Cardinals and Eastern Meadowlarks. Master of sound effects, the starling copies many nonbird sounds—machinery, dogs barking, babies crying, humans whistling, car horns honking—as well as giving a cacophony of chortles, wheezes, and shrieks.

Why do birds mimic? The very word *mimicry* suggests deception, assuming that the bird is actively directing its call toward a specific target. It may simply be, though, that birds mimic to increase the size and variety of their vocal repertoires, better enabling them to claim good territories, impress mates, and repel rivals. Vocal mimicry may not be deceptive at all, leading some biologists to use the term "vocal appropriation" instead. Like hip-hop artists who creatively use music sampling, birds that borrow sounds from others may just be trying to get an edge in a competitive world!

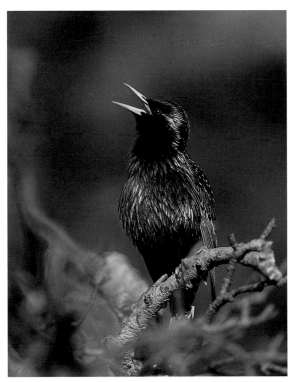

The European Starling sings cover versions of other birds' tunes.

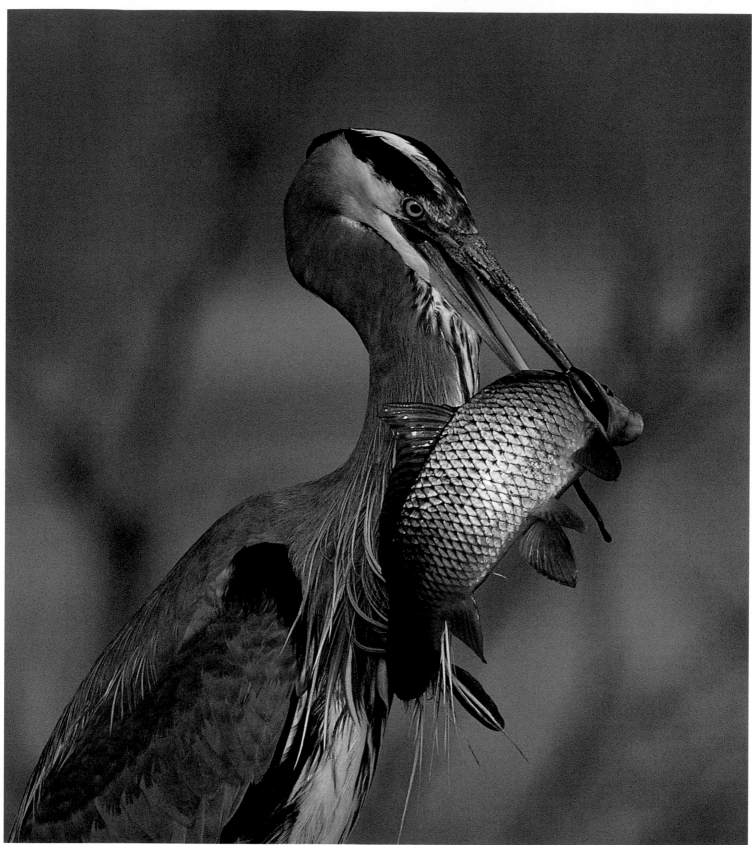

Catch of the day: a Great Blue Heron with an impressive fish.

Bill of Fare

What's for dinner? There's an easy way to tell: just look at the style of a bird's beak. Its shape and size speaks volumes about how the bird makes a living. In fact, the tools and behaviors a bird employs to acquire food can be said to define that bird's very essence.

Birds that live on specialized diets, restricting their food to certain types, have beaks that fit the job perfectly. Beaks of fish-eaters—whether stalk-and-stabbers like the Great Blue Heron or divers like the Belted Kingfisher—are long, narrow, and pointed. So are those of woodpeckers, which dig out insects hidden deep in tree trunks and branches.

Beaks come in a huge variety of shapes and sizes. The beaks of seed-eating birds are triangular in profile, such as the massive tools of grosbeaks and cardinals or the lesser ones of finches and sparrows, made for crushing hard seed coats. Meat-eating birds, hawks and owls for instance, have hooked beaks for tearing at flesh.

Gleaners, such as tiny warblers that pluck insects from vegetation, have thin, pointed bills. Dabbling ducks have flat bills for sifting small food items from the water's surface. Shorebirds use their long bills to probe in mud for worms and other small creatures.

The Great Crested Flycatcher on the right just captured a dragonfly. Typical of flycatchers, it has a broad bill that opens widely to help it snatch insects in flight. And like bills of other aerial insect-eaters, such as swallows and nighthawks, flycatcher bills are surrounded by bristles at the base that may act as a kind of insect net during foraging.

Robins, bluebirds, jays, and crows, though, have beaks that are medium in length and girth, and neither hooked nor very pointed. They tell us that their owners are foraging generalists, able to eat a variety of food types. These birds switch from earthworms to insects to fruit and seeds, depending on what foods are available through the year.

What's the difference between a bill and a beak? The term "beak" was originally used to describe only the hooked jaws of birds of prey, but now the two terms are used interchangeably.

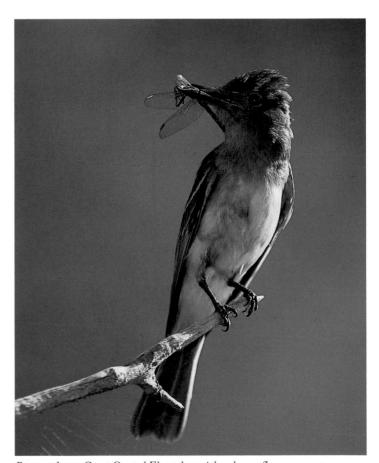

Bug-catcher: a Great Crested Flycatcher with a dragonfly.

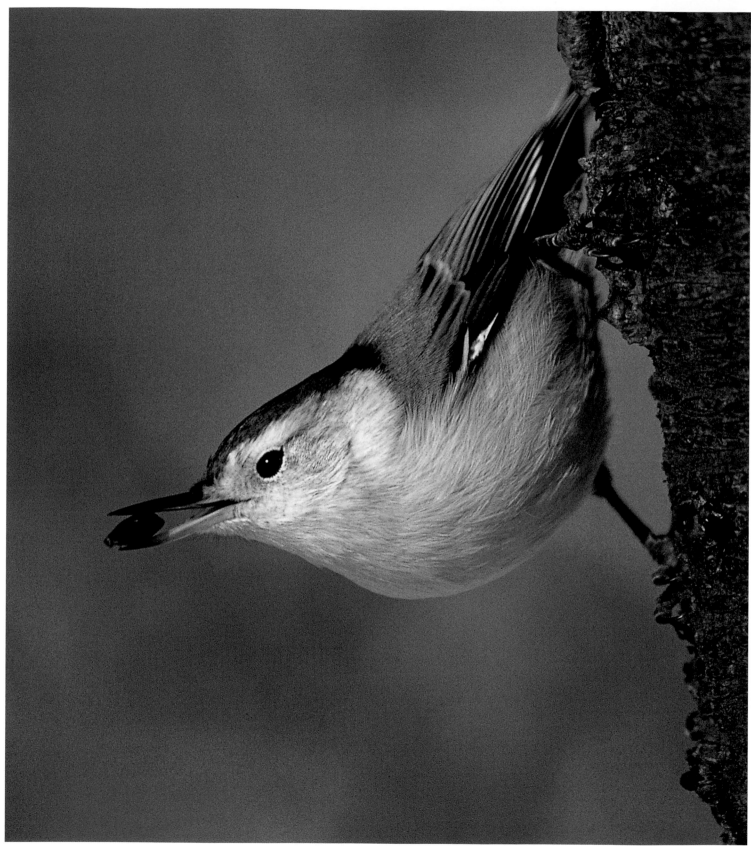

The White-breasted Nuthatch hoards many seeds as food for the winter.

Stashing a Cache

Faced with approaching winter, the White-breasted Nuthatch has a remarkable way of making sure it won't go hungry: in fall it starts caching food. Nuthatches hide seeds behind loose bark, in crevices in tree trunks or branches, or in knotholes, often covering the item with a fragment of bark, moss, or lichen. They may hoard hundreds of seeds around their territory, using each hiding place only once. By spreading the stash around—a behavior known as scatter-hoarding—the bird makes it less likely that its entire winter store will be pilfered by a competitor.

Other winter residents, such as chickadees, titmice, nutcrackers, and jays, hoard food, too. A study of Blue Jays fitted with radio transmitters found that individuals harvest several thousand acorns and other nuts (collectively called "mast") each season. Each jay can carry several acorns at a time, held in its throat and beak. It caches them by burying them singly in the ground at its territory. Any acorns the jays don't retrieve may germinate in spring, making jays important tree dispersers.

Do birds that hoard food really remember all those hiding places later on in the winter and actively seek them out when food supplies dwindle? Or do they simply happen upon the hidden food by chance as they forage around their territories? Experiments on Blue Jays, Clark's Nutcrackers, and chickadees in captivity have shown that they relocate their cached food with surprising accuracy, and much more often than would be expected by chance. Visual landmarks in the natural environment, such as pinecones and rocks, probably help them recognize the locations of their stores.

Far from being "birdbrains," food-caching birds have impressive spatial memory. This type of memory helps animals, including humans, navigate through their environment by keeping track of the relative position of objects in space.

And birds' gray matter underscores this ability. Neurobiologists studying Black-capped Chickadees noticed that areas of the brain that process spatial information fluctuate in size over the year, getting bigger in autumn and peaking in October, the very time that chickadee hoarding activity is most intense.

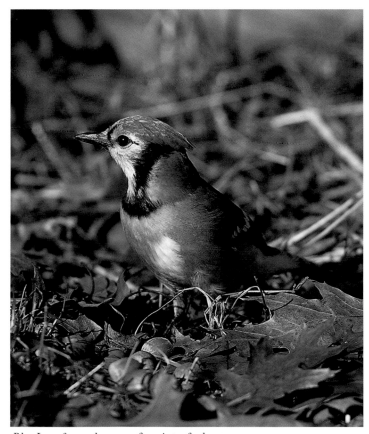

Blue Jays often cache acorns for winter food.

Getting Away from It All

With rushing wings and a clamor of honking voices, Canada Geese lift off from their rest stop in a cattail marsh, starting the next leg of their autumn migration. Skeins of migrating waterfowl against the sky are a familiar sight to us, poignantly marking the cycle of the seasons.

Why do birds migrate? An easy answer is that they must migrate south to avoid the coming winter. But why migrate north in the first place? A more fundamental explanation is that birds migrate because they can. Migration is the strategy that some birds use to take advantage of widely fluctuating resources that are typical of strongly seasonal environments.

Rendered supremely mobile by flight, many species of birds worldwide head toward the earth's poles (northward, of course, in the Northern Hemisphere) to reproduce. They exploit the huge burst of plant and animal life, particularly insects, that takes place during the temperate zone summer. Long midsummer days increase the time available for birds to forage, making the burgeoning food supply even more accessible for the growing youngsters.

When the temporary flush of food dwindles and the environment becomes inhospitable, the migrants move toward the equator, some even beyond it.

Many species of North American shorebirds, whose breeding season in the high Arctic tundra is quickly over, are already on their way back south by late summer. They gather into flocks at food-rich staging areas to rest and put on fat to fuel their flight when their long travel resumes.

Warblers, thrushes, vireos, and other songbirds linger into autumn, waiting for passing weather fronts to bring favorable wind directions that can help them on their way. Finally, by late autumn ducks from breeding areas in North America's heartland pass through, together with geese and swans from farther north.

Unlike those merely traveling between roosting and feeding areas, geese on the move tend to fly high in the sky. And they often fly in a V-formation. One goose leads, the others lining up behind and to each side of it, forming an arrow shape against the sky.

Why they do so is still a mystery. One widely accepted explanation is that the V-pattern is aerodynamically efficient. Each bird but the leader benefits from the lift produced by air swirling around the wing tips of the bird ahead of it, so flock members can travel farther without tiring than if each flew alone. Alternatively, visual, not aerodynamic, forces may be at play. In a V-shaped flock every bird has a clear view ahead and is less likely to collide with its flockmates.

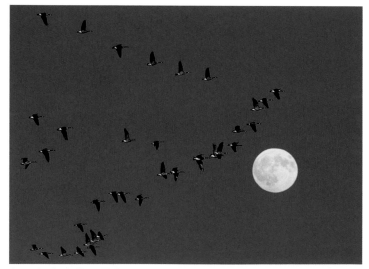

Canada Geese fly in V-formation.

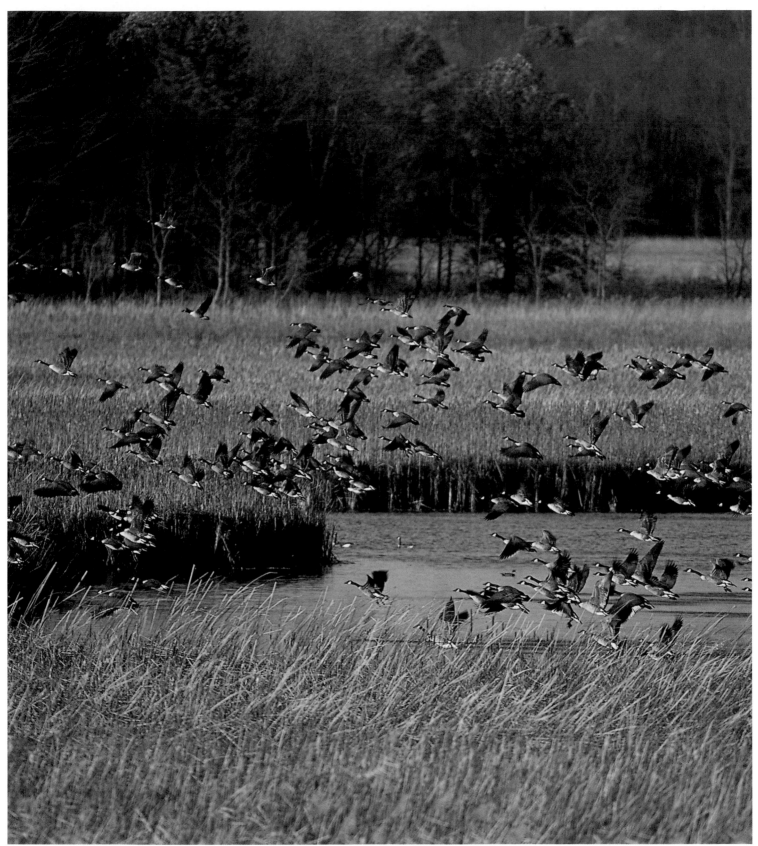

Heading out: Canada Geese take flight from a marsh.

Winter

Season of Survival

Even as winter proves the greatest test of their survival skills, birds come with color and movement to enliven our spirits. With a flash of crimson against the snow-bedecked deep green of a conifer, a Northern Cardinal comes to the feeder. Unusual visitors arrive, fleeing winter from the far north. Redpolls and siskins roam in twittering flocks; crossbills descend on cone-laden evergreens.

The snow itself whispers stories of lives unseen: the tracks of an American Crow searching for food, the delicate imprint of a wing as a bird takes flight.

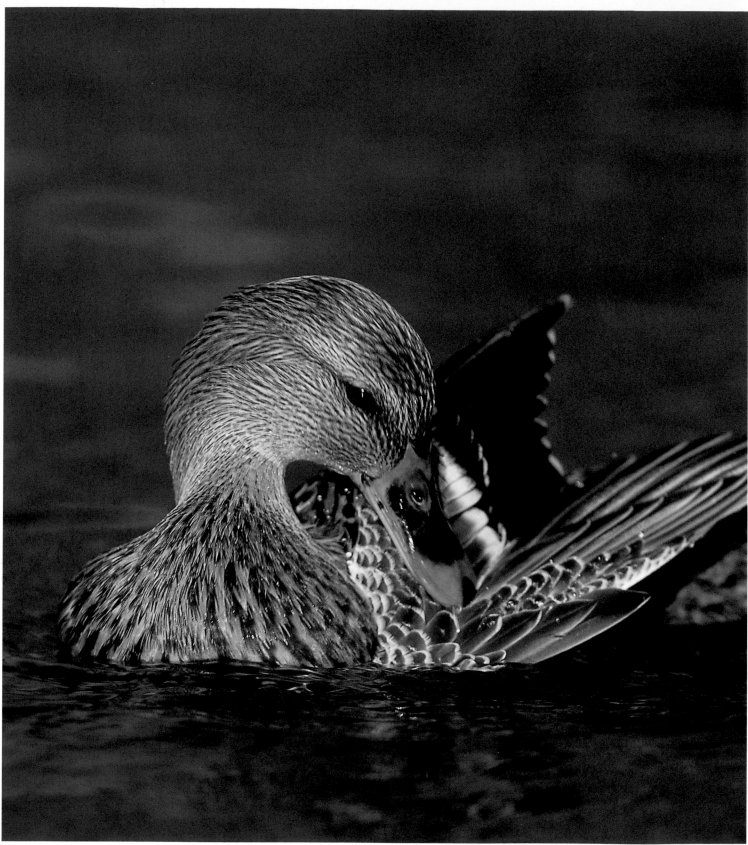

A female Mallard preens her wing.

Primping and Preening

Elegantly posed, a female Mallard begins her morning ritual of feather care. Feathers are essential to birds' health and survival, so not surprisingly birds dedicate much of each day to plumage-maintenance activities such as preening, oiling, bathing, and sunning.

Feathers are remarkably complex. Their intricate structure provides the bird with a warm and waterproof external covering. In combination, their various colors form each bird's characteristic patterning, whether bold markings used in species recognition and displays, or subtle tones and textures that act as camouflage. Most important, feathers are essential to flight. To satisfy all these needs, individual feathers must be kept smooth and in good condition.

Preening helps neaten each feather. The feather vane consists of many fine parallel branches called barbs, each divided into even smaller branches covered with microscopic hooks. As the preening bird draws a feather through its beak, those tiny hooks lock together, aligning the barbs correctly so the feather retains the smooth surface essential for streamlining and insulation. Preening also cleans the feathers. The bird grasps a feather near its base, then nibbles along the shaft toward the tip, removing dirt, stale preen oil, and the occasional mite or louse.

Mystery still surrounds the true function of the oil gland (also called preen gland or uropygial gland), a pimplelike structure on the bird's rump just at the base of the tail. Most birds actively spread oil from this gland onto their plumage as they preen. Preen oil once was considered a waterproofing agent, but scientists now think that the microscopic arrangement of the feather barbs themselves results in feathers' water-shedding ability. Instead, preen oil may be a conditioner to help feathers last longer. Alternatively, it may

be a chemical repellent to control fungal growth or help prevent skin parasite infestation. In certain birds, preen oil has a foul odor that may deter predators. Biologists are currently testing some of these theories.

Watching a bird preoccupied with feather care is great entertainment. Preening birds assume engaging poses, some comical, others beautiful, and, like the preening Chipping Sparrow below, each held for merely an instant. The bird twists and turns, reaching over its back, raising and fanning out its tail, holding up each wing in turn. The head is the hardest to preen: the bird must be content to rub its head against other parts of the body or scratch it with its foot.

A Chipping Sparrow tidies itself up.

Mother Nature's Winter Menu

Leaves have fallen and soon snow will blanket northern fields and forests. Insects have disappeared and the birds that rely on them exclusively have been forced to migrate south to warmer climes. Yet some birds linger late into the year, and still others are permanent year-round residents. These winter inhabitants must continue to make a living.

What's the secret of their success? The answer is flexibility: they adapt their diet to take advantage of nature's harvest.

Eastern Bluebirds feed on insects and other small invertebrates during summer, but in fall and through the winter they eat primarily small fruits. On the right, a male gorges on the scarlet fruit of winterberry, a holly relative that grows in moist woodlands and whose berries persist on the plant all winter.

Winter strategy for bluebirds and robins also involves a flexible migration schedule. They're hardy enough to survive up north if there is an adequate crop of fruit, but they move farther south if fruit is scarce or the winter is particularly harsh.

The top prize for adaptability could easily go to the Black-capped Chickadee, probably the north's most familiar year-round resident. It too has plenty of insects and spiders on the menu all summer, but in winter a more varied diet is the way to go. On the left, a chickadee takes a fuzzy red staghorn sumac fruit. The dark red spikes of various sumac species remain on the tree all winter long, providing a much appreciated food source for many wintering birds. Woodpeckers, bluebirds, starlings, robins, and even Wild Turkeys feed on sumac fruits.

Endowed with boundless curiosity, foraging chickadees use their strong legs to cling upside down. These agile little acrobats probe, prod, and pry into shriveled leaves and dead plant stems, under bark and into tree crevices, searching for dormant spiders or insects and their pupae. Along with crows, jays, nuthatches, small woodpeckers, and titmice, the adaptable chickadee will gorge on energy-rich fat from the corpses of deer and other animals that have met their demise in the woods, until the deepening snow obscures their feast. Plus chickadees eat and store seeds from both natural sources and bird feeders.

A Black-capped Chickadee feeds on staghorn sumac fruit.

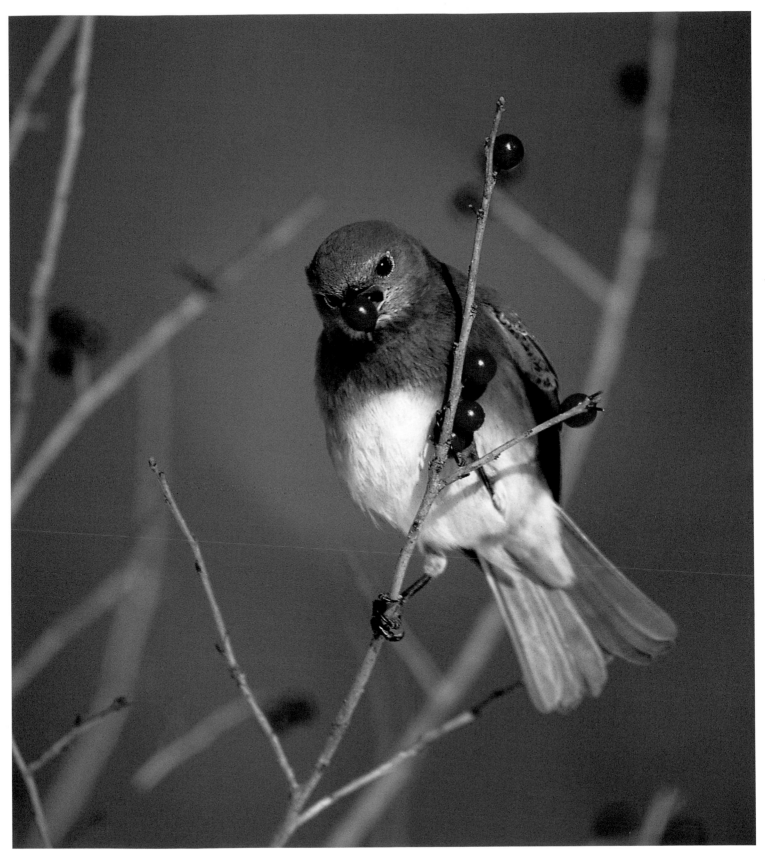

A male Eastern Bluebird gulps down a winterberry fruit.

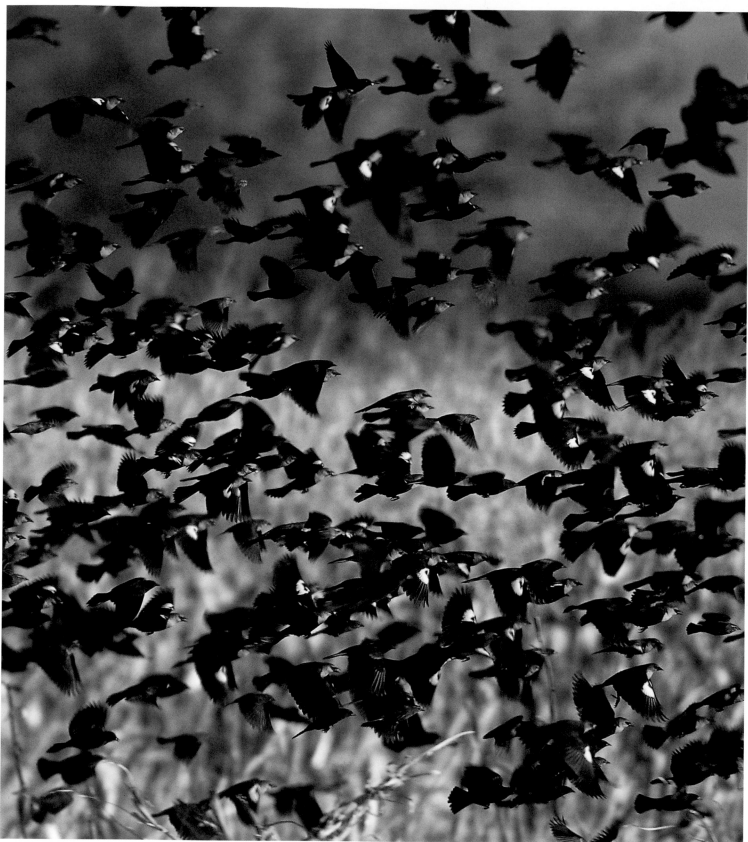

Red-winged and Yellow-headed Blackbirds spend winter in large flocks.

Safety in Numbers

Forming a brilliant mosaic of color, Red-winged and Yellow-headed Blackbirds swirl around a cornfield on their New Mexico wintering grounds. Gregarious passerine birds, such as blackbirds, crows, and starlings, as well as many shorebirds and waterfowl, spend the entire winter in flocks, sometimes in huge numbers.

During the breeding season, holding a territory is the norm for many birds, ensuring they have adequate resources, especially food, near the nest where they raise their young. Freed from that responsibility in winter, birds often gather with others of their kind.

Group living is always a compromise. To be worthwhile, benefits must outweigh costs. On the positive side, there's safety in numbers: many eyes are better than few for detecting danger, even though a group is more conspicuous than a single bird. The larger the group, the less likely an individual will be singled out if a predator does attack. Bird groups are better able to find and exploit food, particularly if it's plentiful but patchily distributed as are fruiting trees, aerial insect swarms, or schools of fish. In these situations there's ample food for all, so it benefits an individual to follow the crowd rather than go it alone.

On the down side, though, group living inevitably leads to competition. Individuals must unwillingly share with other flock members, so squabbles over food and roosting sites occur. Proximity has another serious negative: disease spreads faster when birds are grouped together.

Winter flocks are where young birds learn important survival skills. Tundra Swans, Canada Geese, and Sandhill Cranes tend to stay in family units within their larger flocks even until they head northward once more in spring. Ornithologists believe that the young birds learn the traditional migratory routes they'll use for the rest of their lives from the older, more experienced adults.

Mixed-species flocks often form during the cold months of the year. Chickadees, nuthatches, small woodpeckers, and sometimes kinglets and creepers roam the winter woods, foraging in each other's company. They pay attention to each other's alarm calls to help avoid predation. With more individuals to be vigilant, each one can put more time and energy into searching for food than if it were alone.

Among the most spectacular mixed-species foraging assemblages are the "feeding frenzies" of fish-eating birds. Flocks of cormorants and pelicans pursuing a fish school, like those below, often attract the attention of gulls, terns, mergansers, herons, and egrets. The fish rush to and fro, the diving birds' wings splash, the water boils, and there's a frenzy of snapping bills. In the confusion, a fish fleeing from one bird only ends up in the jaws of another!

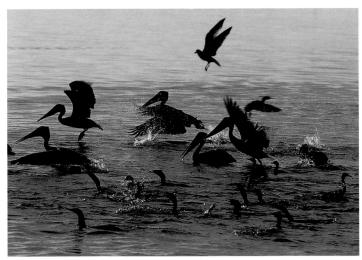

Feeding frenzy: pelicans, cormorants, and gulls chase schooling fish.

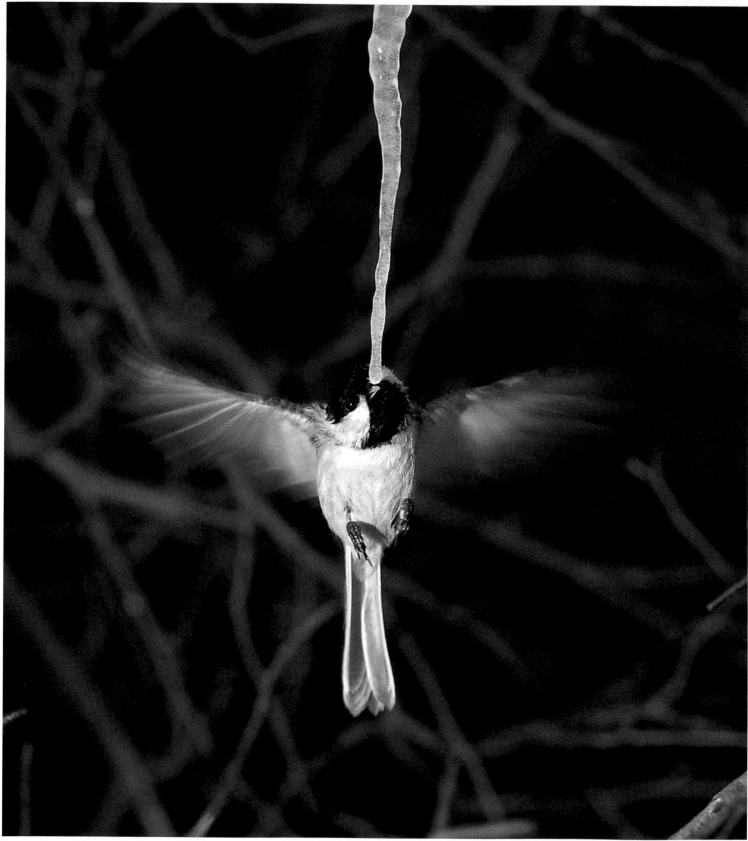

Popsicle for a chickadee: a Black-capped Chickadee hovers to sip from an icicle formed from frozen tree sap.

Popsicles and Snow Cones

Hovering for a fraction of a second like a tiny angel in midair, a Black-capped Chickadee quenches its thirst by snatching a refreshing drop of liquid from the tip of a melting icicle.

Most birds need to drink freestanding water regularly, but in the depths of winter that can be a problem. During long cold spells, ponds, streams, and puddles may freeze solid.

For acrobats like chickadees and kinglets, a melting icicle is one way of solving winter's water scarcity. If the icicle is large, a chickadee may cling to the slippery surface to take a sip. Other birds, such as Downy Woodpeckers, occasionally drink from icicles, too, stretching out to reach them while they cling to branches and trunks nearby.

What about birds that are less capable of aerial antics? Many get water by eating snow. Ground feeders, such as the Northern Cardinal on the right, as well as juncos and sparrows, may do this indirectly when they feed upon snow-covered seeds or fruits. Birds eat snow by itself, too; numerous species, from small songbirds such as redpolls, siskins, and goldfinches, to jays, grosbeaks, various woodpeckers, and ptarmigan, have been observed actively pecking at snow and picking it up in their beaks.

Our agile chickadee finds this particular icicle especially appealing, though: the ice is sweet. When an ice storm snapped a birch limb, the tree's dripping sap froze overnight into a popsicle made just for birds. Ever inquisitive, the local chickadees soon found this "sapsicle," and as it melted and refroze over several days they often visited to sip the sweet liquid. Sometimes a chickadee would even break off a piece of frozen sap from the tip of the icicle, then carry it to a perch and eat it by holding it against a branch with its feet and pecking at it, just as it would do while processing a sunflower seed.

Various birds show a fondness for sweets: when sugar-maple sap begins to rise in early spring, titmice, woodpeckers, and jays, as well as chickadees, are quickly attracted to liquid sap flowing from broken tree limbs. Maybe it was by noticing the birds' excited activity thousands of years ago that North America's earliest human inhabitants first learned about the delights of maple syrup!

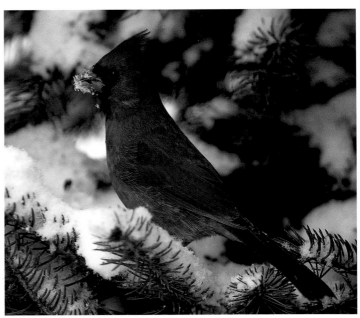

A Northern Cardinal gets some snow with its food.

Insects survive the rigors of winter in various ways, many of which involve hiding, whether under soil or bark, in wood, plant stems, curled-up leaves, or numerous other nooks and crannies. For winter birds, the challenge is to discover these hiding places and extract the food within. A woodpecker has the perfect carpentry tool to access these morsels locked in nature's winter pantry: its bill.

The huge Pileated Woodpecker uses its formidable bill to chisel into trees in which colonies of carpenter ants are overwintering. Once the ants are exposed, the bird licks them up with its long, barb-tipped tongue.

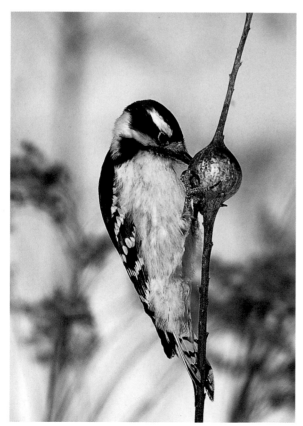

A Downy Woodpecker investigates a goldenrod gall.

In northern regions, dormant ants make up most of this woodpecker's diet during wintertime.

Signs of a foraging Pileated Woodpecker are distinctive. The excavation begins as a square hole, but as the woodpecker works down the tree trunk over the days, exposing more and more of the elaborate tunnels in which the dormant ants reside, it forms a long channel. A woodpecker-width across and several inches deep, it may reach several feet in length. Fresh wood chips on the ground indicate the woodpecker is still active at the tree; keep an eye on it to see the bird in action.

The diminutive Downy Woodpecker, on the left, often searches for food on tree trunks, too. In winter, though, it also directs its insect-seeking activities to small places that larger, heavier woodpeckers cannot reach. Using its small, pointed bill, it taps and pries at corn stalks, plant stems, and cattail seed heads in search of the insect larvae and pupae that make those places their winter homes.

One of its favorite winter foods is the larva of the goldenrod gall fly. The fly lays an egg on a goldenrod stem in summer. The larva burrows in, and its feeding stimulates the living plant tissue around it to form a gall: a spherical swelling in the goldenrod stem. As winter approaches, the larva begins chewing out toward the outside of the gall, stopping just below the surface, thereby forming a tunnel through which it will exit the gall if it's lucky enough to survive until spring. It then retreats to the center of the gall and enters dormancy for the winter.

Along comes the Downy Woodpecker! Tapping on the gall surface, the bird senses the subsurface tunnel and continues pecking away the woody gall tissue, finally claiming its juicy prize.

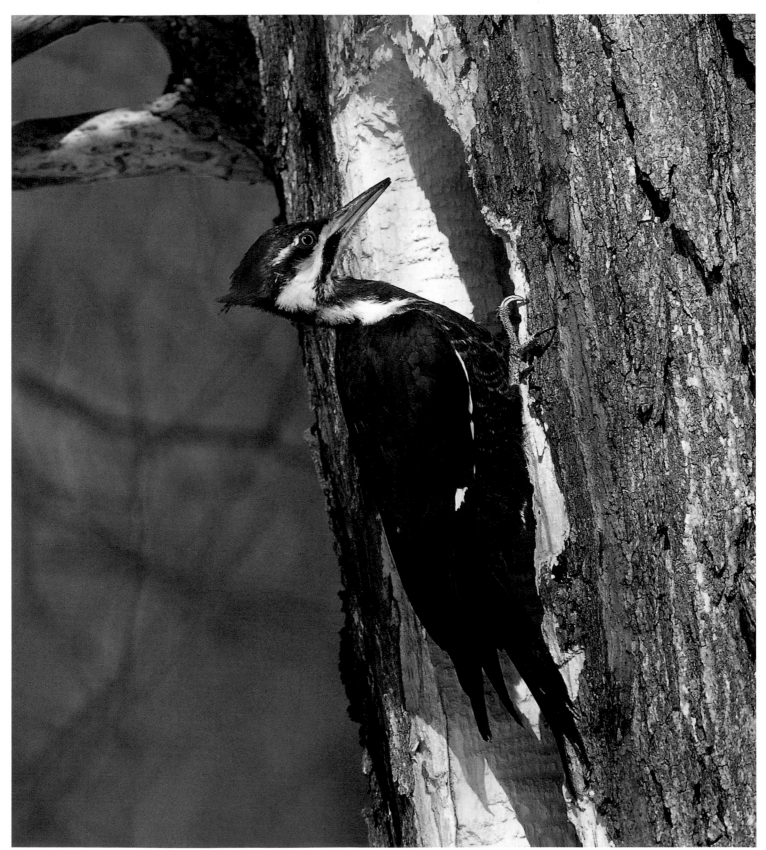

A Pileated Woodpecker excavates for carpenter ants in winter.

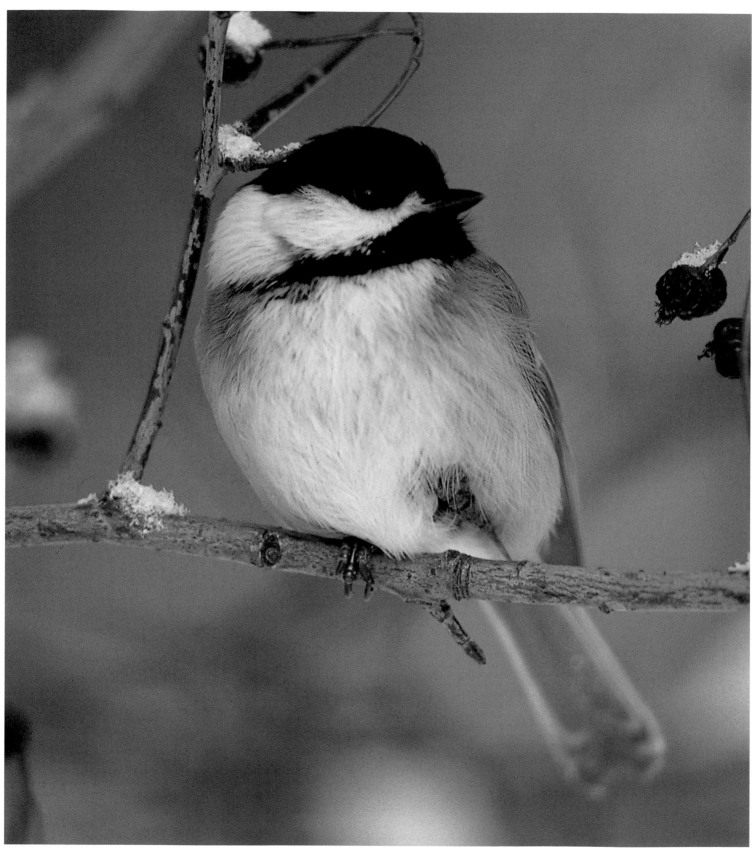

A Black-capped Chickadee warms up one foot on a bitter-cold morning.

Cool Facts About Cold Feet

Feeling the cold while foraging on a frigid winter's day, a Black-capped Chickadee pauses to tuck one of its feet up into its breast feathers to warm it. In a few moments it may switch sides and do the same to the other foot, before continuing the all-important task of finding food.

Temporarily tucking up one foot is just one of several behavioral strategies wintering birds use to retain their body heat. Another is to fluff out their body feathers, much as we would fluff up a down comforter, forming a thicker insulating layer to trap body heat and prevent it from escaping. When perching, chilly birds often squat down low, covering their legs and feet with the breast feathers. Tucking the beak into the breast or shoulder feathers, as herons, ducks, and shorebirds commonly do on cold and windy days, also helps retain warmth.

Gulls and ducks often come out of the water to rest on ice for long periods in winter. Standing on webbed feet means they put a large area of skin in contact with the frigid surface. How do they avoid getting their bodies thoroughly chilled? The answer lies in both behavior and physiology.

Often these birds stand on one foot, as the Mallard on the right is doing, so that only one at a time is exposed to the cold surface. To reduce the heat loss even more, a duck sits down, tucking both feet up into its feathered flanks. In this position it's actually resting on its chest. A dense mat of breast feathers provides a thick layer of insulation against the cold of the ice.

Despite being mostly made up of bone and sinew covered with tough leathery skin, birds' unfeathered legs and feet are a site of potential heat loss in cold weather. Like us, birds can reduce the blood flow to their feet by constricting blood vessels so less blood is exposed to the chilling effect of an icy surface. Some blood flow to the extremeties has to be retained to nourish and oxygenate the tissues, though, so certain birds have developed a still more elaborate physiological mechanism to help them deal with the cold.

Waterfowl and gulls have a special network of tiny blood vessels in the upper part of each leg that acts as a heat exchanger. Because the incoming and outgoing blood vessels lie right next to each other, warm blood leaving the center of the bird's body gives up heat to the cooled blood arriving in veins from the feet. So chilled blood is warmed before it ever reaches the bird's core, and the arterial blood reaching the feet has much less heat to lose to the environment.

This amazing system lets a duck standing on ice stay toasty-warm inside while its feet are only slightly above freezing. Cold feet, warm heart!

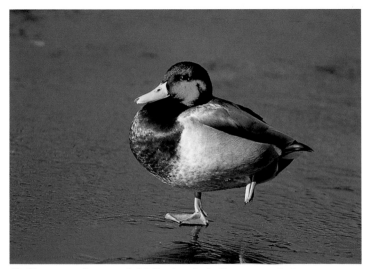

Tucking up one foot, a male Mallard settles in for a rest on the ice.

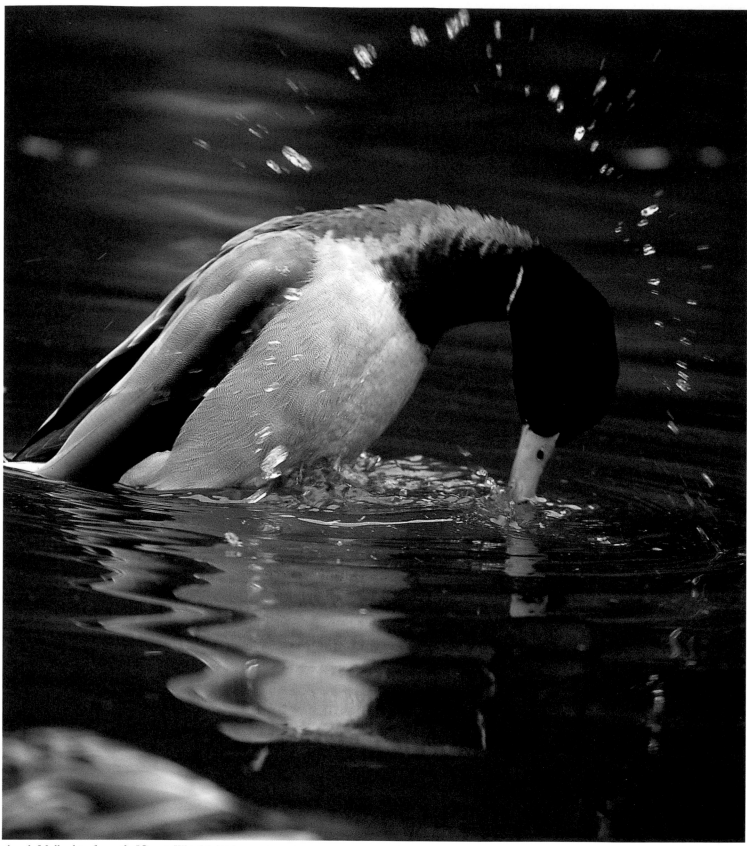

A male Mallard performs the "Grunt–Whistle" display.

The Promise of Spring

With northern regions still in winter's icy grip, a male Mallard, spending winter in the south, is already thinking about love. He's performing a courtship display. Arching his body out of the water, he quickly tosses an arc of water droplets into the air with his bill, giving a sharp whistle at the peak of the action. Called the "Grunt-Whistle" display, his entire performance takes only a second. So if we missed it the first time it pays to keep watching, because he'll probably do it again. Other males around him are performing at the same time, all trying to impress nearby females.

In most duck species, courtship starts in fall and continues until spring. Many Mallards and other waterfowl are already paired by the time they arrive in their northern breeding areas.

Mallard courtship displays happen fast, and it's hard to predict which male will display next. A good way to pick out a courting group of males is that they mill around together agitatedly rather than swimming calmly. Subtle behaviors such as tail shaking and head shaking also signal that a male is about to display.

Courting mallards use several different displays. Some are performed by males in groups toward females, for instance, the "Down-Up" display shown on the right, in which the male tips forward, dips his bill into the water, and quickly flips it out again. In another group display, called "Head-Up-Tail-Up," each male quickly raises then lowers his head, wingtips, and tail, giving a whistling call.

The "Nod-Swimming" display, given by both sexes, is easier to notice. The Mallard swims rapidly to and fro with its neck outstretched and head just grazing the water's surface. This behavior may be done by the female near a group of males, and seems to provoke them into doing their own displays. It's also done by the male around the female after they mate. Just prior to mating, members of a pair face each other and perform a distinctive head-bobbing display called "Pumping." Finally, "Inciting" is a display in which the female repeatedly flips her bill to one side over her shoulder as she follows her chosen mate. It's often done when other males approach the pair.

Mallards are so commonplace that we tend to overlook them, assuming they offer little of interest. Yet watching their elaborate courtship behavior is entertaining and challenging, and helps sharpen our observation skills. It's uplifting as well, especially in winter, a time of year when we ache for the beauty and fascination of nature to nurture our souls.

Even as winter lingers, the resumption of courtship activity brings with it the promise of spring. Our year of exploring bird behavior has come full circle, reflecting the ceaseless ebb and flow of nature's spirit. There's so much more to see. Now it's your turn to discover the secret lives of birds!

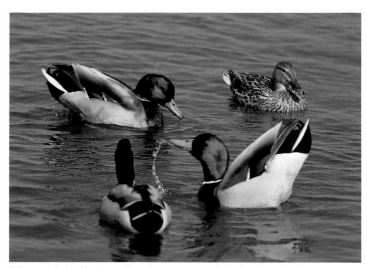

Three male Mallards perform the "Down-Up" display for a female.

Exploring Bird Behavior on Your Own

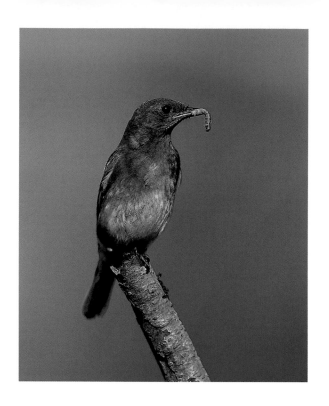

All around us birds are going about their lives, offering us fascinating insights into how they survive and interact with one another. The difference between noticing and missing these secret lives is a little time, a relaxed mind, and some curiosity.

How do you get started watching bird behavior? First you need a bird. Pick a common, conspicuous species: a robin on a lawn, a duck on a local pond, a pigeon in an urban park, or a chickadee at your feeder. Take ten minutes to sit quietly and try to keep track of everything your bird does. You'll probably be surprised at the variety of behaviors you see.

Consider the following scenario. We settle down on a park bench in spring to watch an American Robin. It runs across the lawn in short bursts of steps. It cocks its head to one side, pecks at the earth, then runs

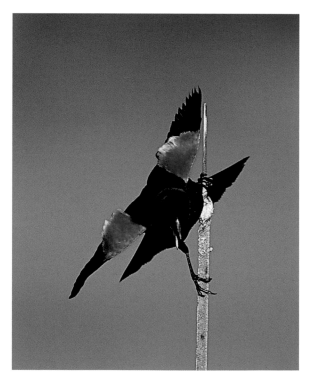

A male Red-winged Blackbird; top right: a male Eastern Bluebird.

again and repeats. Leaning forward, it pecks more intensely at the ground, bracing its body as it pulls out an earthworm. It drops the worm, pecks at it a few times, and finally swallows it. Suddenly a jogger runs past with a dog on a leash. The robin flies into a nearby shrub, flicking its wings and giving sharp *tuk, tuk* calls. Soon it quiets down and begins preening. Then it squats, poops, and flies off, landing at the top of a tree. From high on its perch our robin begins to sing.

In only a short time we've seen how the robin moves on the ground and how it captures and eats prey. We've noted its alarm calls and alarm behavior, and observed preening, defecation, flight, and territorial advertisement.

Whenever we watch birds, particularly their interactions, it's inevitable to want to understand what is happening and why. It's tempting to try to explain bird behavior based on human feelings and motives. Instead, make your observations objectively. Try to watch exactly what happens rather than immediately interpreting the events.

Notice how various parts of the bird's body change as its behavior progresses. If it has a crest, is this raised or lowered during each activity? Is its plumage fluffed or sleeked? Is it standing tall or squatting low? What are its wings doing: are they raised, drooped, fluttering? Pay particular attention to any sounds that occur. When more than one bird is involved in the behavior you're observing, what does each do before, during, and after the interaction? Does your bird act differently when it is in a flock than when it is alone? Observe different species feeding: how do their methods differ?

Birds easily become alarmed by abrupt movements, so keep as still and quiet as possible. They will quickly become used to you and soon will go about their natural behavior. You may be surprised how closely they approach you if you remain patient. Remember that most bird activity takes place in early to midmorning, then again in late afternoon. At midday, particularly in warm weather, birds tend to be inactive.

The best places to watch bird behavior are those that are attractive to birds and where birds are used to seeing people. Choose a site where birds gather naturally, such as a feeding area or a water source. City parks, local duck ponds, and your own backyard are great places to start.

Watching at a nest can be thrilling, but approaching too closely may keep the adults away and endanger the young. Instead, watch from a distance, using binoculars to avoid disturbing your subjects. Avoid removing vegetation to improve your view, because this exposes the nest to predators.

One of the delights of bird behavior is how it changes with the cycle of the seasons. An interesting and revealing project is to return to your favorite bird spots regularly to check up on the progress of the birds' lives.

Now let's explore some of the different types of behavior you're likely to see.

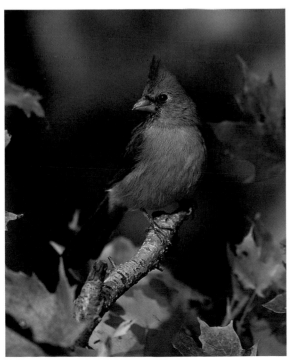

A female Northern Cardinal.

Male and female Mallards.

Types of Bird Behavior

Most bird behavior can be classified into one of two types: social behavior or maintenance behavior. Social behavior includes all the interactions between a bird and others of the same or different species. Maintenance behavior encompasses all the daily activities a bird uses to take care of its body. Bird flight is behavior that forms an essential part of activities that fit in both categories. Information about the technical aspects of flight, beyond our scope here, can be found in some of the books mentioned on page 90.

SOCIAL BEHAVIOR One of the most exciting aspects of birds' lives is how they interact with others during such social activities as defending territories, courting mates, nesting, raising young, and flocking. Birds' level of sociability changes with the seasons; they may be gregarious at certain times of year yet highly territorial at others. Some of the most fascinating behavior occurs in spring and summer when birds

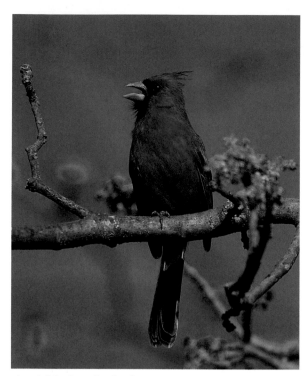

A male Northern Cardinal.

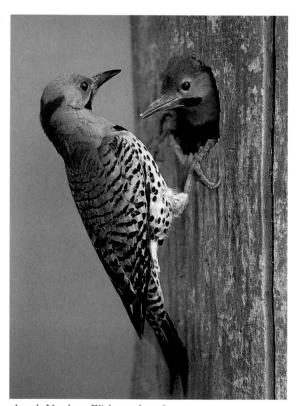

A male Northern Flicker and nestling.

are engaged in breeding. During a social interaction, an individual is coordinating its activities with those of another. This inevitably requires communication, often by means of displays.

Displays: A bird posturing or moving in a way that actively signals information to another bird (whether the same or a different species) is said to be performing a display. Displays are birds' body language. To human eyes, some bird displays may look odd, even bizarre, but they are essential aspects of bird behavior. Displays are classified according to function: courtship, aggression, distraction, and so on. Courtship displays often focus attention on some aspect of the male's appearance, allowing the female to judge his quality. For instance, the display may accentuate part of the male's plumage, such as the Red-winged Blackbird's scarlet shoulders. Aggressive displays often make the aggressor appear larger and more threatening, for instance by fluffing plumage or raising the wings. A display may be a purely visual signal, but it may also include sound. Birds' songs themselves are often thought of as audi-

tory displays, as are the functionally similar advertising calls and nonvocal sounds given by nonsongbirds.

Songs and Calls: In birds, the term "song" generally refers to the complex, musical sounds produced by songbirds, usually males, during territorial activities. Simpler sounds are referred to as "calls." Yet certain calls are given for the very same reasons as song: owls hoot and doves coo to establish territories and attract mates. Calls are given for other reasons, too. Alarm calls alert others that danger is present. Contact calls maintain group cohesion or help members of a pair keep track of each other's location. Nestlings' begging calls encourage their parents to feed them.

MAINTENANCE BEHAVIOR Keeping its body in prime condition is vital for a bird's survival. Maintenance behavior, sometimes called "comfort" behavior, is important year round, changing little through the seasons. Body-care activities include feeding and drinking, both of which take care of the bird's internal state or physiology. Birds gather and process food in a wide variety of ways, all fascinating to watch. A bird's external covering gets active upkeep, too. Birds spend a lot of time caring for their plumage by preening, oiling, bathing, and sunning, although feather and skin condition also rely on adequate nutrition. Finally, rest and sleep are important for keeping birds in good health, too.

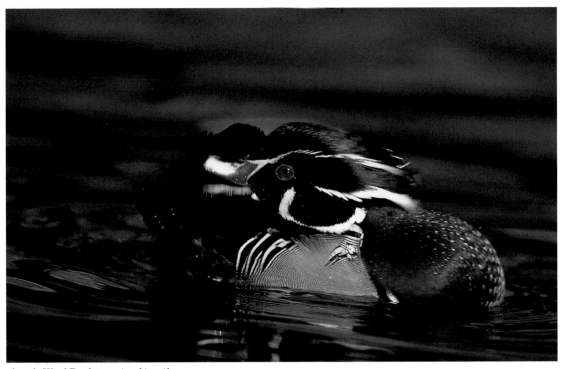

A male Wood Duck preening his tail.

We hope that the window into birds' lives we've shared in this book will inspire you to become a watcher of bird behavior even if you are already a birder. The world of birds is yours to discover, and the adventure starts just outside your door.

Enjoy exploring the secret lives of your favorite birds!

Sources and Further Reading

Many of the behaviors and situations that I describe in this book are based on my own observations during many hours spent sitting in photo blinds watching birds going about their lives while waiting for that perfect moment to trip the camera shutter. For accurate interpretation, I have relied upon the sources listed below and the expert knowledge of various friends and colleagues who study birds for a living.

SOURCES

A Guide to Bird Behavior, Volumes I-III. Donald W. Stokes and Lillian Q. Stokes. Boston: Little, Brown, 1979, 1983, 1989.

The Birds of North America: Life Histories for the 21st Century, **Nos. 1-716.** A. Poole and F. Gill, editors. Philadelphia: Birds of North America, Inc. (also on-line at: http://bna.birds.cornell.edu/BNA/)

Handbook of Bird Biology. Sandy Podulka, Ronald W. Rohrbaugh, Jr., and Rick Bonney, editors. Ithaca: Cornell Lab of Ornithology in association with Princeton University Press, 2004. (Formerly *Home Study Course in Bird Biology.*)

The Birder's Handbook: A Field Guide to the Natural History of North American Birds. Paul R. Ehrlich, David S. Dobkin, and Darryl Wheye. New York: Simon and Schuster/Fireside Books, 1988.

FURTHER READING

The following are excellent resources for those who would like to explore bird behavior in more depth.

Bird Flight: An Illustrated Study of Birds' Aerial Mastery. Robert Burton. New York: Facts on File, 1990.

Music of the Birds: A Celebration of Bird Song. Lang Elliott. Boston: Houghton Mifflin, 1999. (Includes an audio compact disc.)

How Birds Migrate. Paul Kerlinger. Mechanicsburg, Pa.: Stackpole Books, 1995.

Nature's Music: The Science of Birdsong. Peter Marler and Hans Slabbekoorn, editors. Burlington, Mass. Elsevier/Academic Press, 2004. (Includes two audio compact discs.)

The Sibley Guide to Bird Life & Behavior. David Allen Sibley. New York: Alfred A. Knopf/Borzoi Books, 2001.

Acknowledgments

This book would not have been possible without the help of the many friends and former strangers who offered information, helped me find subjects, and welcomed me into their gardens, fields, and woodlots to photograph "their" birds. I'm ever grateful to all of you.

Thanks to long-time friends Lang Elliott and Karen Allaben-Confer for their unwavering support during this project, and to ornithologist and friend Kevin McGowan for making sure I had my facts straight while allowing me artistic license here and there!

Special thanks to my husband, Peter Wrege, field biologist extraordinaire and designer of this book, whose knowledge, creativity, and enthusiasm for bird biology are a constant source of inspiration.

Finally, this book is dedicated to the memory of my parents: to my mother, Joyce, for her loving encouragement, and to my father, Lewis, who sowed the seeds of a lifetime's love of nature in his child's heart.

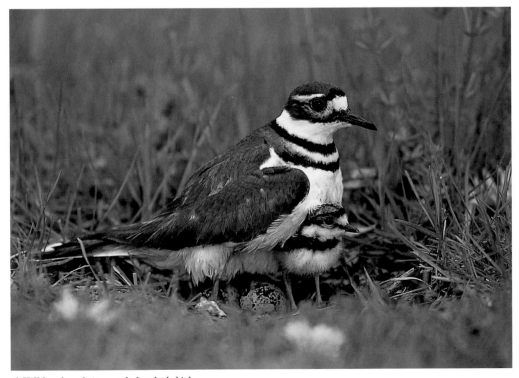

A Killdeer broods its newly hatched chick.

Subject Index

Italic numbers refer to pages with photogaphs.

Index to Featured Birds

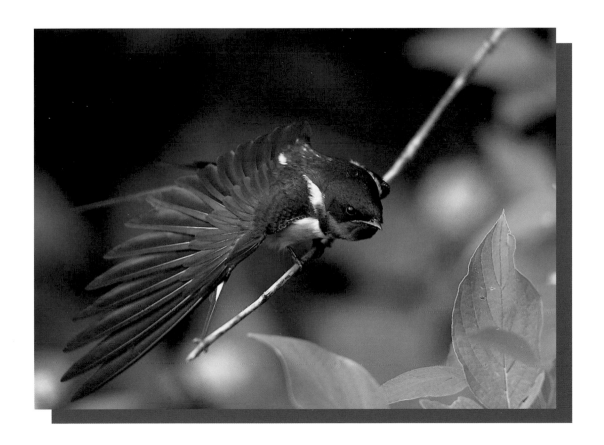

May you always have birds to watch!
Marie Read

January 2005, Freeville, New York

Taking a bow: a Barn Swallow stretches its wing.